The Bakelite
Jewelry Book

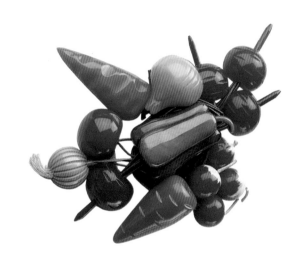

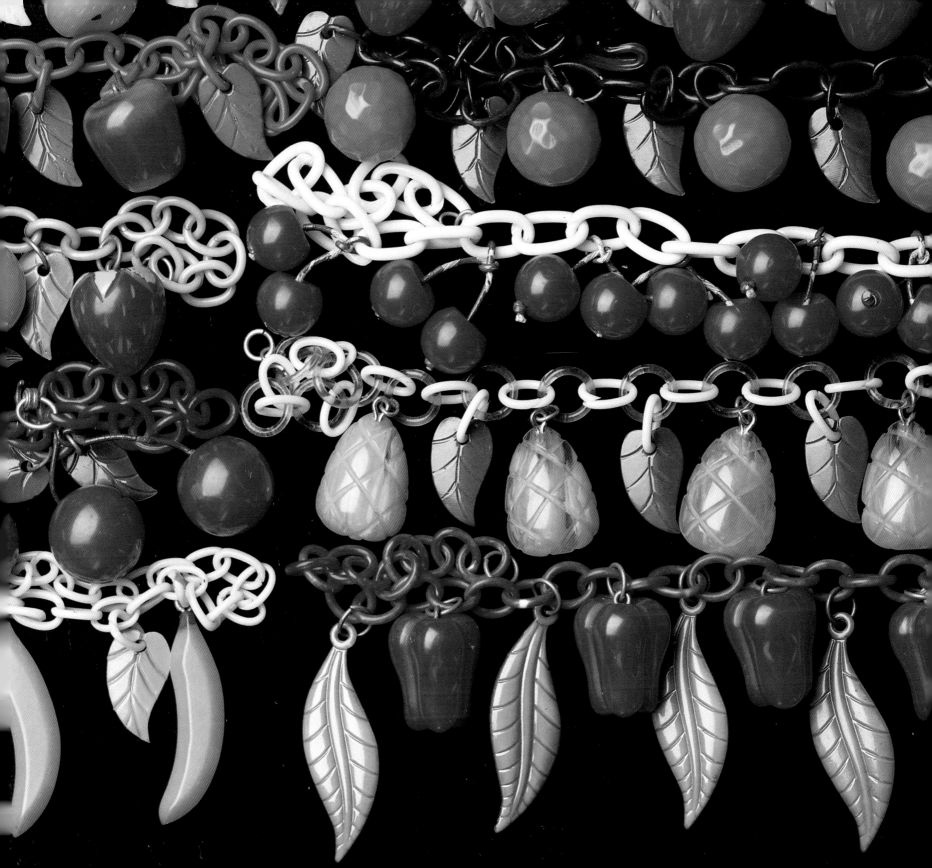

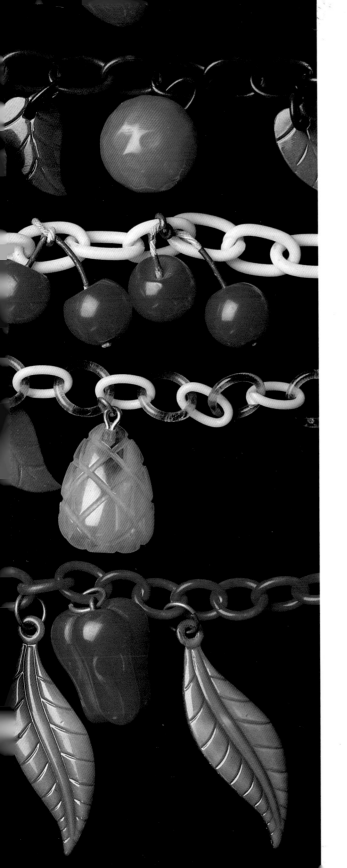

The Bakelite Jewelry Book

Corinne Davidov

Ginny Redington Dawes

Photography by Steven Mark Needham

Abbeville Press Publishers
New York · London · Paris

Editor: Walton Rawls
Designer: Renée Khatami
Copy Chief: Robin James
Production Supervisor: Hope Koturo

Library of Congress Cataloging-in-Publication Data

Davidov, Corinne.
 Bakelite jewelry.

 Bibliography: p.
 Includes index.
 1. Plastic jewelry—Collectors and collecting.
I. Dawes, Ginny Redington. II. Needham, Steven
Mark. III. Title.
NK4890.P55D38 1988 745.594'2'09043075
 88-16653 ISBN 0-89659-867-5

Contents

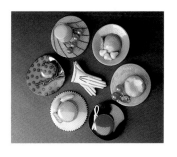

A Word About Bakelite

"Bakelite" is the brand name for the first thermosetting plastic, which was invented by Leo Hendrik Baekeland in 1907 and manufactured by his General Bakelite Company (later the Bakelite Corporation). It is now a registered trademark of the Union Carbide Corporation. Bakelite's uses ranged from the purely industrial to the colorfully decorative, and it was the forerunner of all thermosetting plastics made from cast phenolic resins.

All of the jewelry found in this book was made from cast phenolic thermosetting plastic, though not necessarily that produced by the Bakelite Corporation. Besides Bakelite, plastics made from cast phenolic resins include the brand names Catalin, Marblette, Ivaleur, Joanite, Phenolia, Durez, Durite, Gemstone, Prystal, Agatine, Fiberlon, Trafford, and Monsanto Phenolic Resin, but it is undoubtedly to Bakelite that they owe their genesis. For this reason, and for the sake of simplicity, we have referred to all the cast phenolic jewelry in this book as "Bakelite."

6

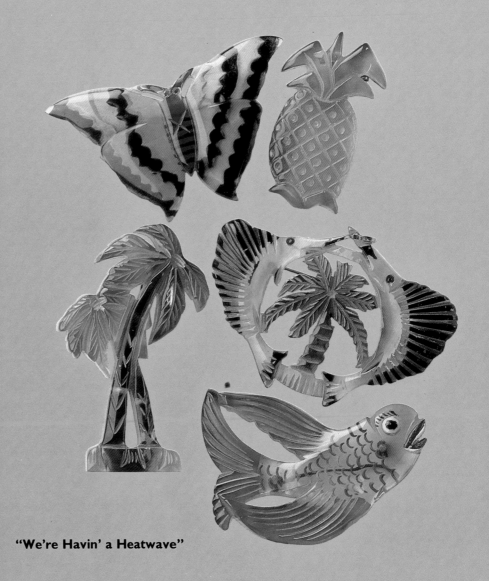

"We're Havin' a Heatwave"

Acknowledgments

Our deepest gratitude to our husbands, Ted Davidov and Tom Dawes, for their interest, help, and support, and to Tom Dawes for taking the additional photographs for this book and for his preliminary editing. The major portion of the jewelry featured in this book is from three collections: the authors' own and that of Dr. Robert Lerch and Wendy Friedman, to whom we owe special thanks. Many thanks also to Lesley Miller, Shelly Broutman, Fred and Kathy Giampietro, Diane Petipas, Raquel Hicks, Lois Cone, Alice Denney, Barbara Pollack, Audrey Friedman, Arlene Kogod, Joan Goldfarb, Richard J. Peters, and Louise Pinson for allowing us to photograph their "pet" pieces; to Karen and Kathy Davidov for their valuable research and knowledgeable assistance; to Fred Schwartz for his experienced legal guidance; to Tony Romeo for supplying all those wonderful Thirties song titles; to Roger, Marion, and Rod Mouré for granting us an informative interview and lending us pieces from their original sample line; to Louise Ogilvie for her special "best friend's" view of Martha Sleeper; to Kate Urquhart for unearthing unusual research material; to Paul Koring for his journalistic assistance; to Gordon Kline, formerly of *Modern Plastics*, and his wife Dorothy; to John Hull of the "Plastics Pioneers"; to Françoise Abriou of the French Embassy and Pierre Chanal of the Mairie D'Oyonnax; to Jerome Gold for Juliet Man Ray in Paris; to Robert Harding of the Smithsonian and Margaret Van Buskirk of the Metropolitan Museum of Art's Costume Institute; to Robin Mullin, Bosha Lipton, Tim Campbell, Elizabeth Hine, Nina Hyde, Lenore Benson, Jackie Jaffe, Eleni Epstein, Hilda Gaddis and John Allen-Gifford for their special efforts; to Walton Rawls, our editor, Renée Khatami, our designer, and the folks at Abbeville Press; and to the New York Public Library for just being there.

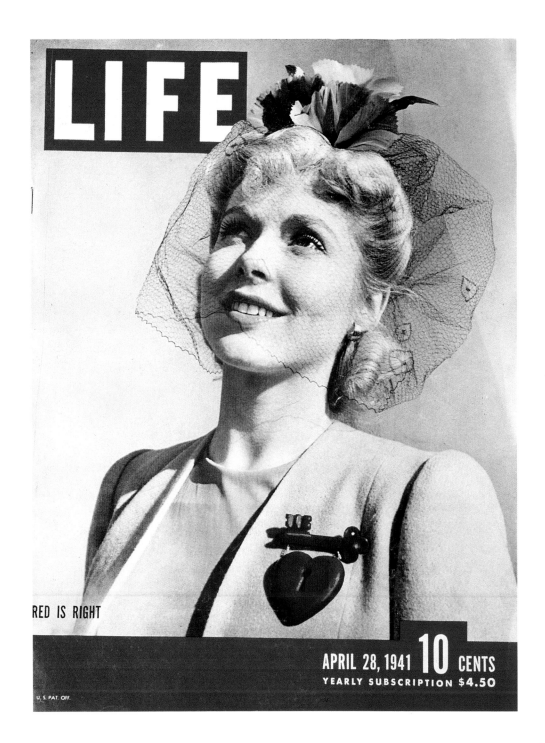

LIFE

RED IS RIGHT

APRIL 28, 1941 10 CENTS
YEARLY SUBSCRIPTION $4.50

U. S. PAT. OFF.

Introduction

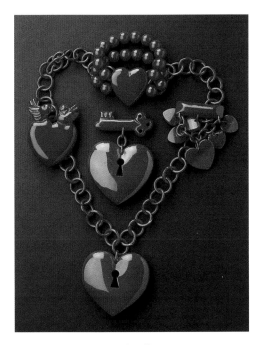

"My Funny Valentine"

We first became aware of Bakelite jewelry about fifteen years ago, but we had no name for it. There on the cover of an old (April 28, 1941) issue of *Life* magazine was a black-and-white photo of a pretty model wearing an enormous, red heart brooch. The accompanying article reported that red was the "in" color for spring. But what was the pin made of? And who made it? And why? Nowhere in the entire article was there any reference to the brooch. What could be so unusual now but so absolutely common then as to deserve no mention? It was obviously some sort of plastic, but different from the plastics of today, possessed of a depth and a density, a richness of color, and a glow unlike anything else.

The plastic, we later found out, was a cast phenolic resin—Bakelite—used in the manufacture of,

among other things, Depression-era costume jewelry. Bakelite jewelry inspired a fashion trend that began, spread like wildfire, grew to gigantic proportions, and died away all within a few short years—flourishing little more than a decade, particularly between the years 1933 and 1941. But like many enchanting things of an earlier period, it has re-emerged as a desirable collectible, something to search for, admire, cherish, and wear.

The purpose of this book is to illustrate the amazing range, the indefatigable humor, the high style, the good-hearted silliness, the stream-lined chic, the daring inventiveness, the color, and the form that characterize Bakelite jewelry. It is emblematic of a unique culture that only could have blossomed between a depression and a world war. A sign of the times, Bakelite baubles were a valentine to optimism, a what-the-hell

9

10

gaiety, a feeling of "making hay while the sun shines." So what if you had no money! Just pin some dime-store cherries on your old blue serge lapel, tilt your felt chapeau, and go get 'em! Like Fiestaware, cocktail shakers, and bridge parties, Bakelite jewelry was indisputably compatible with a national mind-set. And like the popular songs of the thirties that espouse the philosophy of an entire generation, Bakelite jewelry sheds its own light on the tenor of the times. It is definitely a walk on "the sunny side of the street."

The eighties have witnessed an astounding resurgence of interest in the cast phenolic jewelry of the thirties. For the collectible-buying public, there is a growing infatuation with these gay and very wearable pieces of the period. For the serious collector, there is fierce competition for the rare, quality pieces made in limited numbers. Because of this, Bakelite seems to be everywhere. Each year, the Manhattan Antiques and Collectibles Expo features a staggering array of it. In the south of France, thousands of people flock to the plastic museum of the Centre Culturel Aragon. In the movie *Radio Days* Woody Allen bedecked his actresses with it. *Connoisseur* magazine's July 1985

issue devoted the cover and a sumptuous eleven-page spread to it, and in January 1987 the Sunday supplement of London's *Daily Mail* reported on Patrick Cook's Bakelite Museum Society and his annual "Phenolic Picnic"! On April 24, 1988, record prices were set at Sotheby's New York for the extensive Bakelite collection in the Andy Warhol estate.

In short, Bakelite jewelry is alive and holding up very well for its fifty-odd years. Join us in celebrating a distinctly individual, freewheeling, and high-spirited style of expression.

Prized Bakelite bracelet from the Andy Warhol auction.

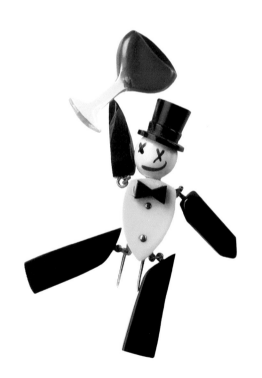

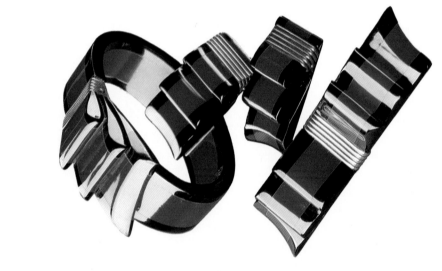

Early Plastics

An unusual "painting" made of Bakelite formica depicting the plastic-making process.

14

Plastic, which comes from the Greek word *plastikos* (to mold), applies to substances that can be molded and shaped. The earliest plastics were natural, like amber, tortoise shell, horn, and shellac. But plastic has, more recently, come to stand for primarily synthetic substances that can be molded and formed under pressure or heat.

Today there are three major categories of collectible plastic jewelry: pyroxylin (Celluloid), casein (Galalith), and cast phenolic (Bakelite). The earliest semisynthetic plastic was pyroxylin, also called xylonite, which was a combination of cellulose (plant fiber), nitric and sulfuric acids, and camphor. Its development was begun in 1855 by an Englishman, Alexander Parkes, under the name Parkesine. In 1868, under the brand name Celluloid, it was refined by John Wesley Hyatt of Newark, New Jersey, in an attempt to make simulated-ivory billiard balls. Its greatest virtue was thermoplasticity: the quality of being malleable under heat; its biggest drawback: violent flammability and explosiveness. Needless to say, it did not make a great billiard ball, but it was good for collars and cuffs, vanity sets and toilet articles, and for the imitation of natural plastics.

Celluloid's most important early use was for photographic and movie film, but after numerous tragic movie-theater fires, the much-less-flammable cellulose acetate replaced celluloid in photography.

Next came Galalith, a casein or "milk" plastic, so called because it was made from a protein substance derived from sour milk combined with formaldehyde. Invented by German chemist Adolph Spitteler in 1897, Galalith was a plastic of glossy beauty, harder than celluloid, that

16

"Singin' in the Rain"

could also be molded by heating. It was not, however, strong or moisture resistant, and it had a tendency to warp. But it was a wonderful decorative material because of its outstanding color range and luminous pastels. Also known by the brand names of Erinoid, Karolith, and Aladdinite, it was used primarily in the manufacture of small things: hair combs, buttons, buckles, knitting needles, fountain pens, and jewelry.

Casein plastics were very popular in Europe and were just beginning to catch on in America when a superior, tougher, more adaptable plastic stole the show and revolutionized the entire industry. This was *Bakelite.*

In 1907, in Yonkers, New York, a Belgian-born chemist named Leo Baekeland was searching for a substance to compete with natural resins and shellacs. He combined phenolic resin with formaldehyde in the presence of a catalyst and heat, and accidentally discovered a material that was nonflammable, intractible, and capable of withstanding 100,000 volts of electricity! This new material was the first entirely man-made plastic and the first *thermosetting* plastic— that is, one that hardened permanently when cured and could not be softened again with the application of

heat. It was the most irrevocably hard of all plastics, but still warm to the touch; it was tasteless, odorless, stainless, moisture resistant, of colors that would neither fade nor chip, and it could be polished to a gemlike luster.

Proclaimed the "material of a thousand uses," Bakelite was first employed in electrical insulation and heat-resistant radio, telephone, and auto parts. The Bakelite Corporation made two general categories of phenolic resins: the cast and molded types. With fillers like wood flour and asbestos added for extra strength, objects made of molded Bakelite were dense, utilitarian, and dark in color. For making costume jewelry, cast phenolic resins (to which no filler was added) were used because they possessed better decorative and color properties and because they did not require expensive molds and molding equipment. Instead, they were cast in liquid form, hardened slowly in ovens over a period of days, and converted into consumer goods by machining. The colors were still quite limited (red, green, yellow, maroon, brown, and black were the whole spectrum), but there were no limits to the decorative uses of phenolic resins in cutlery,

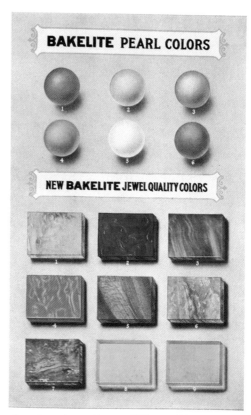

17

A color chart from *Gifts to Treasure,* a 1924 catalog of Bakelite jewelry put out by the Embed Art Company to illustrate "the brilliance of amber, the lustre of jet, the glow of emeralds, the fire of rubies . . . of the new Bakelite Jewel Quality Colors."

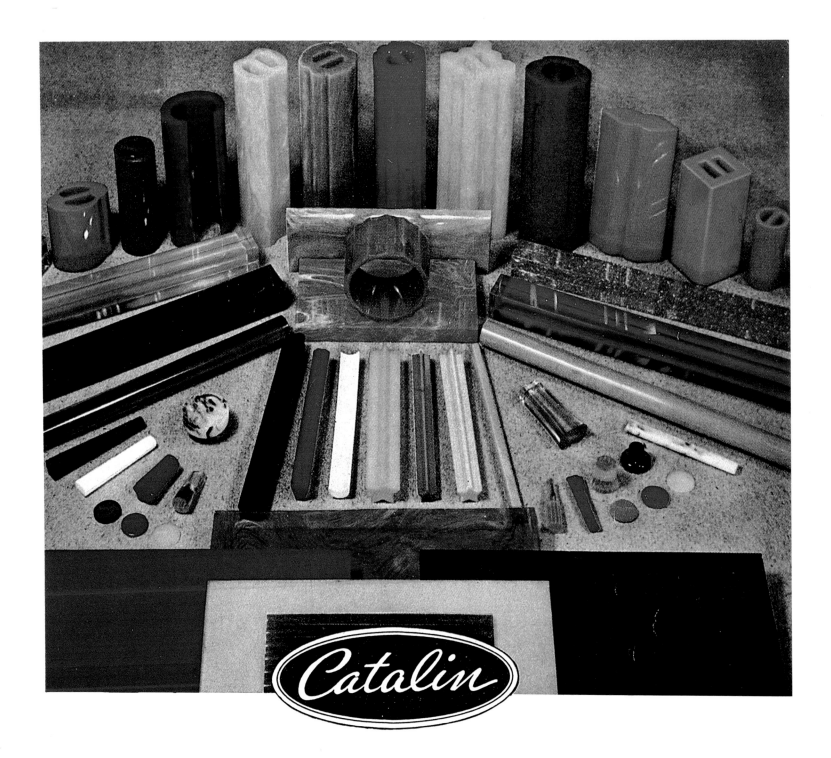

kitchenware, smoking articles, desk sets, vanity sets, poker chips, chess pieces, billiard balls, radio cases, clock cases, umbrella handles, and, of course, costume jewelry.

In the early thirties, the Catalin Corporation brought forth a newer phenolic, Catalin, which took color well and was extremely attractive. Catalin captivated the plastic industry with its more than two hundred opaque, marbleized, translucent, and transparent colors. Breakthrough that this was, it did not delight everyone. A writer for *Fortune* magazine's March 1936 issue ended a description of Catalin on this sour note: "Shudder for the future. . . . Nothing else can match Catalin in potential gaudiness."

Raw materials came from the factory in standard tubes, rods, and sheets of varying lengths and sizes for the making of belt buckles, bracelets, and brooches. One of the beauties of Bakelite was how easily it could be worked. Like metal and wood, it could be sawed, sliced, threaded, ground, drilled, and sanded, as well as carved into intricate shapes and polished in big rolling tumblers to the smoothness of glass. Thus, the makers of buttons and buckles bought rods and tubular stock and machined that into finished articles. Bracelets were sliced from stock tubes and then carved by artful machinists. Pins and brooches were usually cut from quarter-inch sheet stock and shaped with jig saws. Because of the potential toxicity of the waste material produced in its machining, a suction-exhaust device was installed at each operator's station to carry away dust and chips.

After a piece was machined, tool marks and a general surface roughness had to be polished away in a large tumbler filled with wooden pegs and pumice. Findings such as hinge screws and decorative metal embellishments were then drilled or cemented into place.

Bakelite was so readily workable that it became extremely popular with the amateur craftsman. Home kits, from which things like bracelets and jewelry boxes could be made, were widely sold.

As the first entirely synthetic plastic, Bakelite can be distinguished from other plastics by its depth, its heft, its shine, and (some say) a certain alchemical seductiveness. Indeed, Bakelite seems to have bewitched many of today's collectors, and, apparently, ardent feelings for this substance are not new. A religious-sounding little text from 1924 called "The Bakelite Story," by John Kimberly Mumford, recounts the creation of Bakelite in such glowing terms that it would seem to have been surpassed only by *the* Creation. The last paragraph is particularly uplifting:

19

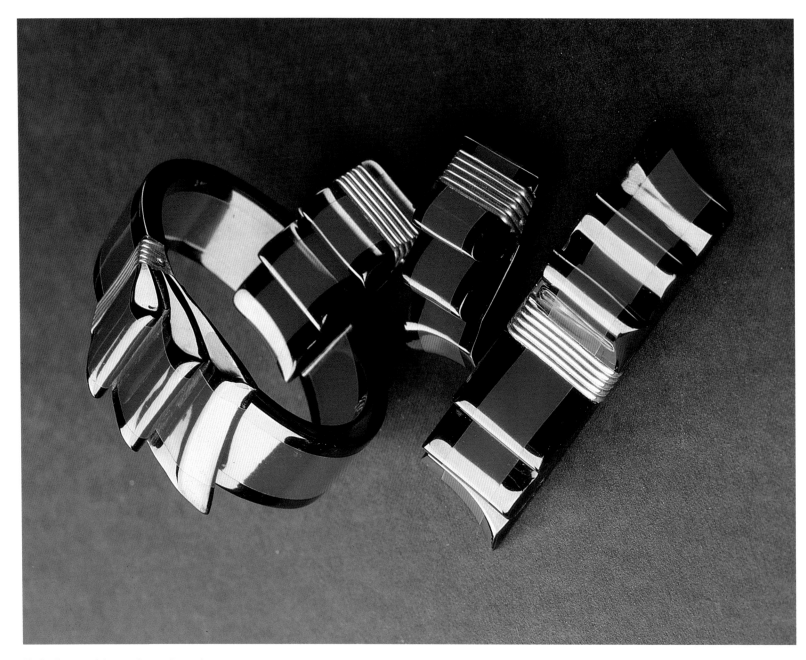

Bakelite and brass bracelet, pin, and
clips.

It is all "over, over there," but wherever wheels whirr, wherever women preen themselves in the glitter of electric lights, wherever a ship plows the sea or an airplane floats in the blue—wherever people are living, in the Twentieth Century sense of the word, there Bakelite will be found rendering its enduring service.

Amen!

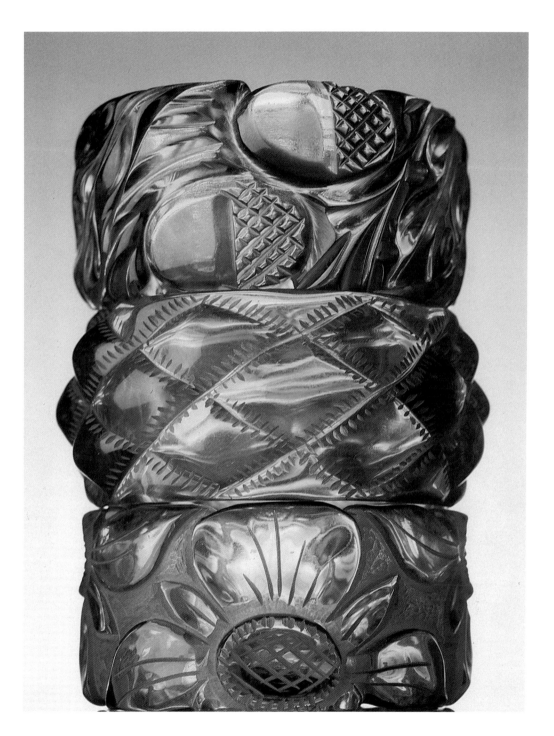

The Father of Plastics

Leo Hendrik Baekeland was born in Belgium in 1863. As a student at the University of Ghent, he amazed his professors with his brilliant work in the field of chemistry. At only twenty-one years of age he was awarded a doctorate in natural science *maxima cum laude*. He then became a professor at the University of Bruges, where he won first prize in a chemistry competition that paid for his ticket to America. Shortly thereafter he invented Velox, a photographic printing paper that could be exposed and developed very quickly and easily. Ten years later he sold the rights for this process to George Eastman of the Kodak company for a reported million dollars.

According to Bernard Wolfe in his book *Plastics,* it was lucky for the plastics world that this fortune did not go to Baekeland's head or change his frugal ways. It was this frugality

that, in a sense, was responsible for the invention of Bakelite.

Doctor Baekeland had a small, makeshift laboratory set up in a converted stable in the backyard of his home in Yonkers, New York. It was there that he repeatedly tried to produce a synthetic shellac. When he combined phenol (carbolic acid) with formaldehyde, he found that the mixture refused to be poured from his test tube. Nevertheless, the thrifty Doctor Baekeland, never one to throw away a test tube, was determined to clean it. First he applied heat, in the hopes of melting the heavy syrup, and thoroughly shook the test tube. But the syrup had become petrified. Then he tried a series of solvents, but not one of them had any effect. Believing he was on to something, he went over his actions step by step and found that phenolic acid combined with formaldehyde in

"Forty-Second Street"

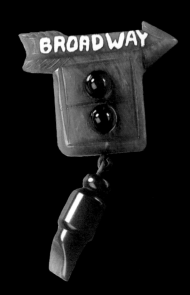

the presence of an alkaline catalyst, when heated and agitated, produced a curious rock-hard substance that was impervious to solvents. And although he was disappointed that synthetic shellac had once more evaded him, he was excited by what he had found—oxybenzylmethyleneglycolanhydride (more commonly known as "Bakelite")—the first thermosetting plastic.

A chemist named Richard Seabury of the Boonton Rubber Company became interested in Baekeland's new discovery and asked him for samples. Seabury blended some of Baekeland's resin with asbestos filler, and Bakelite, the perfect material for electrical insulation, was born. The rest is, as they say, history.

In 1910, Baekeland formed the General Bakelite Company, with headquarters in Perth Amboy, New

ration, as it was subsequently named, was acquired by Union Carbide.

Baekeland listed for *Time* magazine (whose cover he graced in 1924) forty-three industries he believed would find his new invention useful. In 1940, *Time* reported that "today it would be hard to find forty-three in which it is *not* used." It has even been suggested that Bakelite played an important part in the development of the atomic bomb.

The "Father of Plastics" died in 1944, but, oddly enough, Baekeland's name has resurfaced in the last few years—and not because he was the inventor of Velox or Bakelite. It has to do with a book called *Savage Grace* by Natalie Robins, which recounts a chilling tale of incest and homicide: the 1972 murder by Leo Baekeland's great-grandson, Tony, of his own mother, Barbara Baekeland.

23

Fashion History

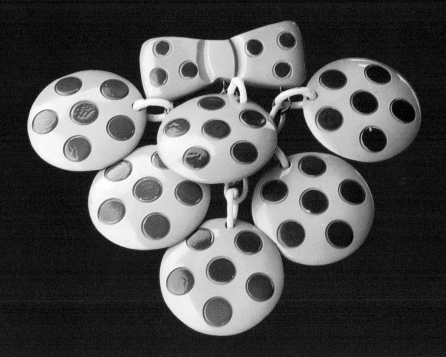

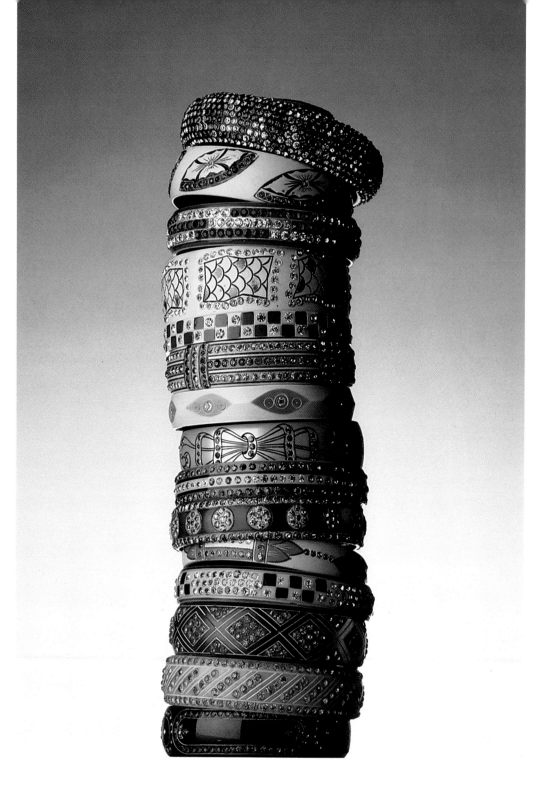

Stack of celluloid bangles.

the popularity of plastic costume jewelry began in 1918 with the end of the First World War. On both sides of the Atlantic there developed an epidemic of giddiness that produced the "Roaring Twenties," with its snappy jazz beat and new sex symbol: the Flapper. Doing the Charleston, she was the "cat's meow" with bobbed hair, short skirt, mile-long beads, and glittering bracelets. Those bracelets, many of them worn on the upper arm, were made of celluloid and rhinestones in geometric and serpentine motifs. Some, with an Egyptian flair, were inspired by "Tutmania," a fad of the twenties that celebrated the opening of Tutankhamen's tomb.

Heavier, more massive bracelets became popular when Nancy Cunard, the famed shipping heiress and socialite, returned from an African safari wearing armloads of ivory bangles.

Her travels and fashion whims were always noted in the press, and a sketch of Nancy by Cecil Beaton in a 1929 issue of British *Vogue* was captioned, "Miss Nancy Cunard lately came to London to buy more barbaric bracelets."

The fledgling decorative-plastics industry jumped on the bandwagon and began turning out cast phenolic "barbaric" bangles in pseudo-ivory, jet, and jade; but following the Crash of 1929, a failed economy and a somber mood seemed to have suspended all new ideas and activity. Later, as the Depression gradually receded, limited production was resumed, and many women who once could afford fine jewelry were now more attracted than ever to the new plastics, because of their novelty *and* low cost (20 cents to $3 apiece).

In the late twenties, designer Coco Chanel greatly improved the image of

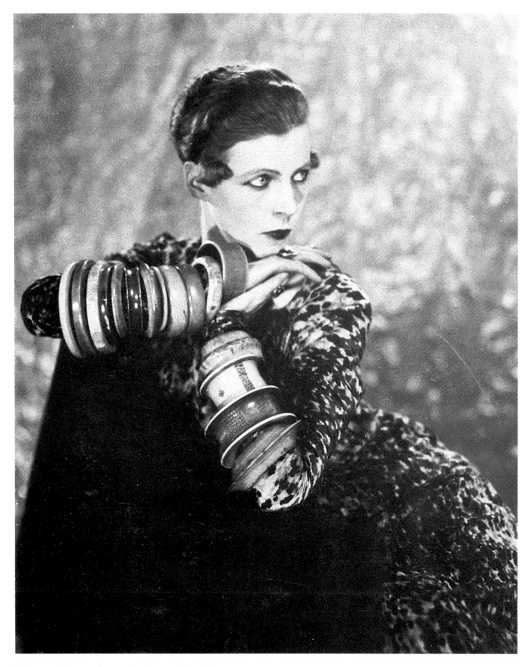

Nancy Cunard as photographed by
Man Ray, 1926.

plastic with her espousal of "frankly fake costume jewelry" to be worn with her couture. She opened a boutique introducing to the public her newest jewelry and accessories. Included in this collection were Bakelite bracelets set with enormous colored stones. Four of these bracelets, belonging to the fashion arbiter and former editor of *Vogue* Diana Vreeland, were recently auctioned off at Sotheby's for hefty sums. Chanel was a champion of the dress clip—which, when it was introduced in 1930, became the most common piece of jewelry of the following decade, and a requisite for all manufacturers of Bakelite jewelry.

In the early thirties, plastic buttons were the biggest seller, and very often designers used them as a distraction from lesser-quality fabrics. *Fortune* magazine observed that "when times get bad, dress manufacturers cut their costs by emphasizing buttons in the creation of new styles." No one did more for the button than designer Elsa Schiaparelli, who used buttons of every conceivable variety, on everything from hats to bathing suits! Her originality and whimsical designs of butterflies, bugs, and fairy lanterns sparked the imagination of the entire fashion industry.

French-inspired rhinestone and Bakelite bracelets.

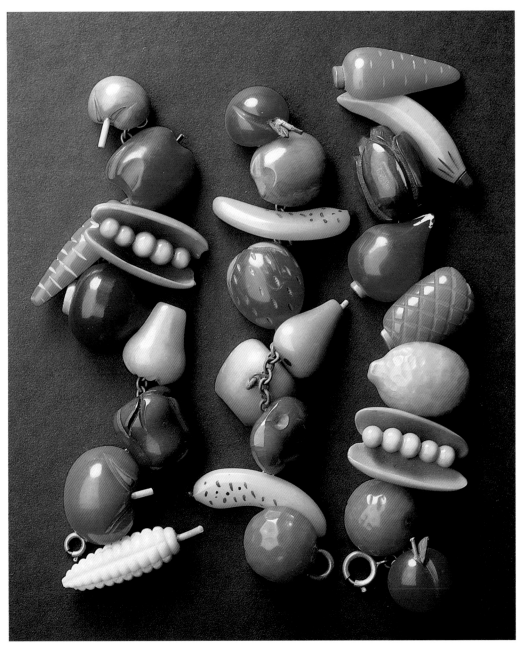

Bracelets made from colorful Catalin "fruit" buttons.

Inspired by Salvador Dali's Surrealism and Pablo Picasso's Cubism, France's beloved "Schiap" and her extraordinary accessories designer, Jean Clement, knew no bounds. Buttons suddenly took the shape of padlocks, telephones, lips, peanuts, roller skates, mushrooms, and lobsters. From her autobiography, *Shocking Life,* came this quote of a review: "King Button still reigned without fear at Schiap's. The most incredible things were used: animals, feathers, caricatures, paperweights, chains, locks, clips, and lollipops. Some were of wood and others were plastic but not one looked like what a button was supposed to look like."

More sedate couturiers such as Vionnet, Hubert, and Vienne endorsed the use of plastic materials for spectacles, handbag frames, brooches, and dress clips. As if this were not enough, Worth and Goupy designed accessories in Bakelite and rhinestones to be worn with formal evening wear, and Cartier made fine watches with Bakelite cases!

Meanwhile, with the election of Franklin D. Roosevelt as President, there was hope for a new beginning for America and a brighter future. His New Deal promised job opportu-

31

nities for millions. Roosevelt was so popular that his pet Scottie dog, Fala, became the national mascot and decorative symbol for the decade.

Offering a continuing respite from post-Depression cares and woes, Hollywood was cranking out musical comedies. Bing Crosby was singing "Pennies from Heaven," and Fred Astaire and Ginger Rogers were tapping to "Pick Yourself Up, Dust Yourself Off, Start All Over Again," on a floor made of Fred's favorite dancing surface—you guessed it—

Bakelite! The country was movie crazy, and the plastics industry took advantage of this by using stars like Ginger to model their products.

Out of this changing climate stepped the Thirties Woman: strong, independent, and able to weather just about anything. Dressed in rayon, the new miracle material, she sported optimistic, brightly colored print dresses in floral, polka-dotted, and geometric patterns, and, on her arms, Bakelite bangles in accompanying motifs.

In 1935, tweeds for women became fashionable, and a whole new sporting way of life was born. Women loved the pedal-pushers, culottes, bell-bottom trousers, and playsuits it spawned. And on the lapels of their plaid, tweed, and camel jackets, they rakishly pinned an accompanying piece of novelty or "sports" jewelry. The variety of subject matter and design was endless: a baseball pin for a trip to Ebbets Field, a yachting necklace for a boat ride, a horse's head for an equestrian event.

32

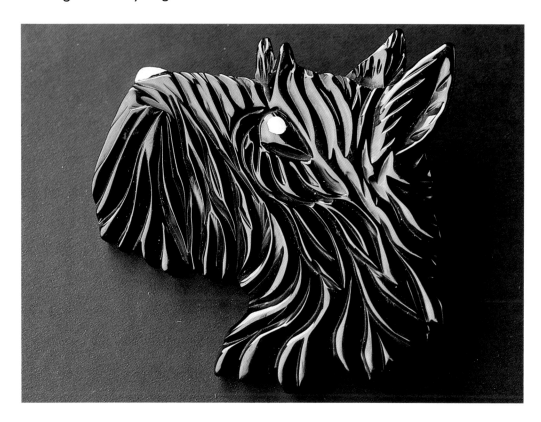

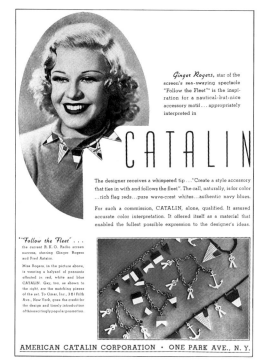

Ginger Rogers.

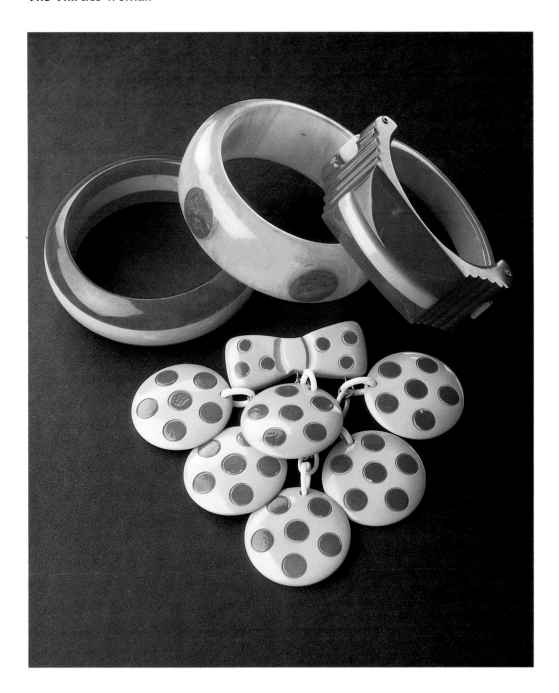

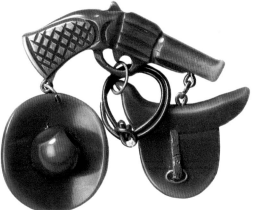

An amusing piece of "sports" jewelry.

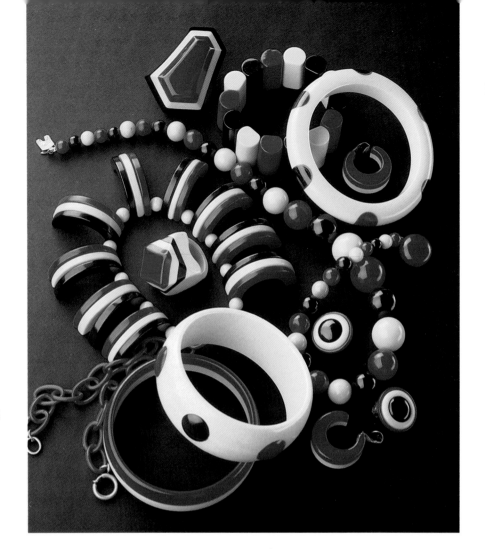

Mix-and-match jewelry.

These pieces were often offered in sets replete with matching necklaces, bracelets, pins, clips, rings, earrings, buttons, and buckles. McCreery's Department Store, in New York City, invited its customers to "assemble your own accessories." Indeed, the mid-thirties were a time of extreme accessory consciousness, and the ever-changing fashion needs re-quired just such a material as Bakelite, which was easily fabricated, lightweight, and durable.

Besides the five-and-ten-cent stores, where the low-priced end of Bakelite jewelry met with phenomenal success, department stores like B. Altman, Lord & Taylor, Bergdorf Goodman, and Saks Fifth Avenue in New York, and Harrod's and John

Dickinson and Son in London, and Printemps, Bon Marché, and Galerie Lafayette in Paris did a large business in better-quality plastic. Bakelite jewelry was also sold in specialty stores like Aspreys, Miriam Haskell's, and DePinna. The sets sold in these stores were given romantic names like "Bois Glacé," "Regatta," and "Harlequin," and were produced in exotic sounding colors like "Araby Green," "Devon," and "Dubonnet." If a planned promotion of, say, Mexican print fabric needed matching paraphernalia, a plastics fabricator would be called upon to make up "sombrero" buttons and buckles. America was entranced by "Far Away Places," and the plastic jewelry designs of the times reflected this with Oriental,

35

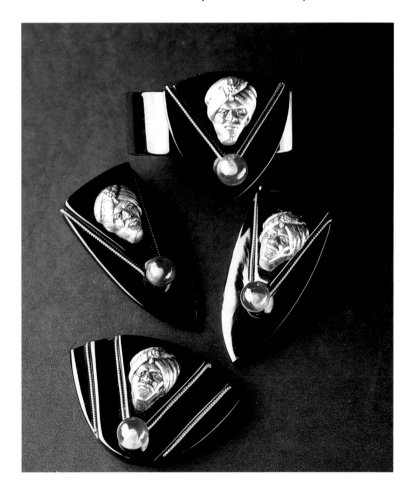

Swami bracelet, pin, and dress clips.

Hawaiian, and Spanish themes abounding. Historical events also inspired timely creations in Bakelite. In 1940, Lord & Taylor sold gilt-metal and plastic replicas of ancient Chinese jewelry to benefit Madame Chiang Kai-shek's fund for war orphans.

So conspicuous had the plastic jewelry industry become that in July 1935, courtesy of the Marblette Corporation, Macy's in New York featured a window display entitled "Fashion Jewelry," in which rods, sheets, and tubes of cast resins were arranged to show step-by-step how these materials were machined and carved into finished goods.

By 1936, 70 percent of all costume jewelry sold was made of cast phenolic resins, and for the next few

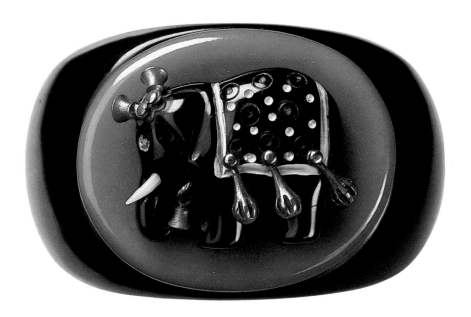

Exotic bracelet illustrating the "Oriental" influence.

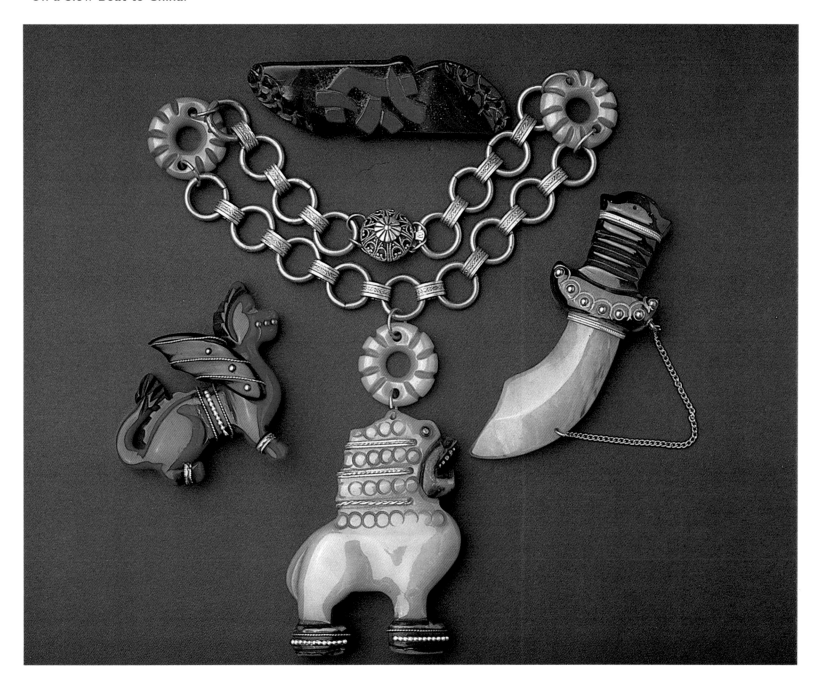

years Bakelite jewelry continued to enjoy a widespread popularity, especially in combination with other materials like wood, glass, vermeil, and metal, as well as other plastics such as cellulose acetate. By the late thirties, however, there were warning signs that pointed to a decline. *Modern Plastics,* a trade magazine of the period, predicted: "Low material costs, low fabrication costs, and high fabrication speeds are the three factors that invite design piracy with its inevitable cheapening of quality and destruction of price structures."

But, in the end, it was not ease of piracy that caused the demise of the cast phenolic jewelry industry: it was World War II. From a Catalin ad of 1942:

Two bracelet and pin sets: Bakelite and wood "acorns" and Bakelite and brass "holly."

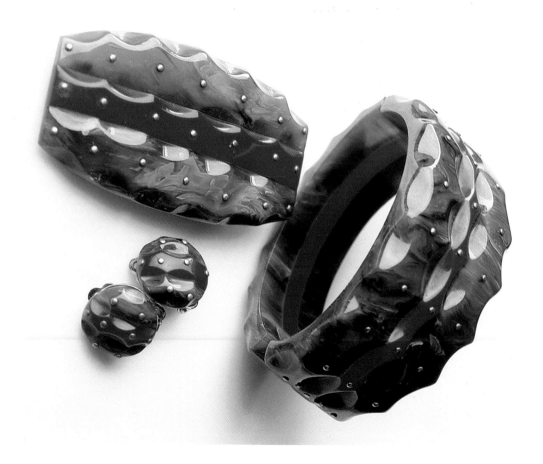

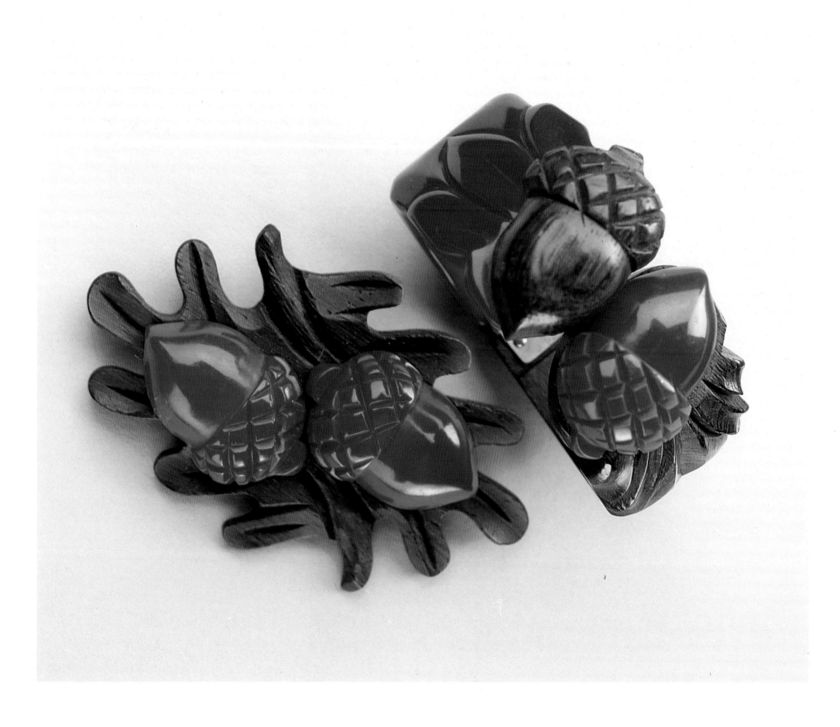

Stack of clear "deco" bangles.

Today, luxury items must step down and make way for things essential to defense. We therefore pause to lift a toast—to our exquisite creations, and to the time when the Gem of Plastics will again be at the disposal of our valued customers.

Sadly, because of the postwar economy and changing technology, this was never to be.

40

renowned costume jewelry collection owned by former editor of *Vogue* Diana Vreeland. The last word in fashion from 1930 to the present, Mrs. Vreeland, now in her eighties, still enjoys the position of special consultant to the Metropolitan Museum of Art's Costume Institute.

bers that the buttons were designed by Jean Schlumberger, who was one of Schiap's great jewelry designers.

Feisty as ever, Mrs. Vreeland, when asked why Bakelite jewelry was enjoying such a resurgence of popularity, quickly replied, "Silly! Fashion *is* revival!"

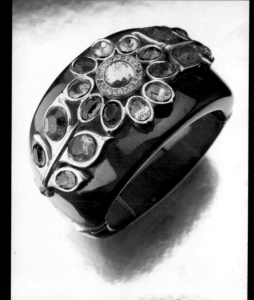

Chanel bracelet.

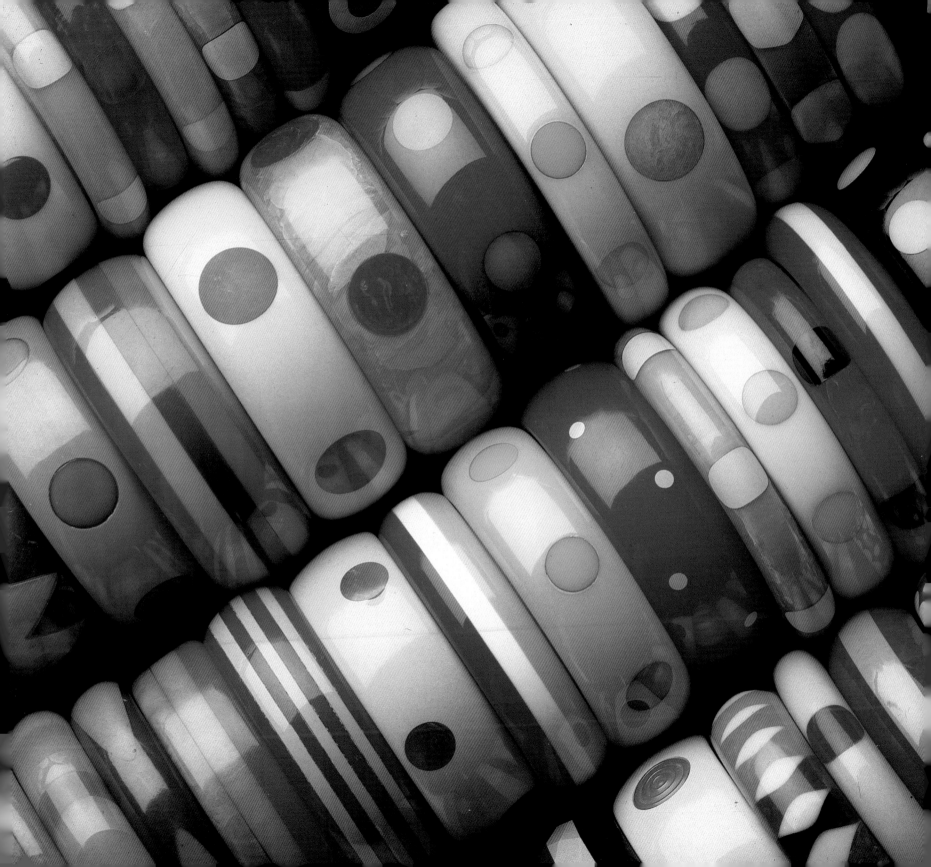

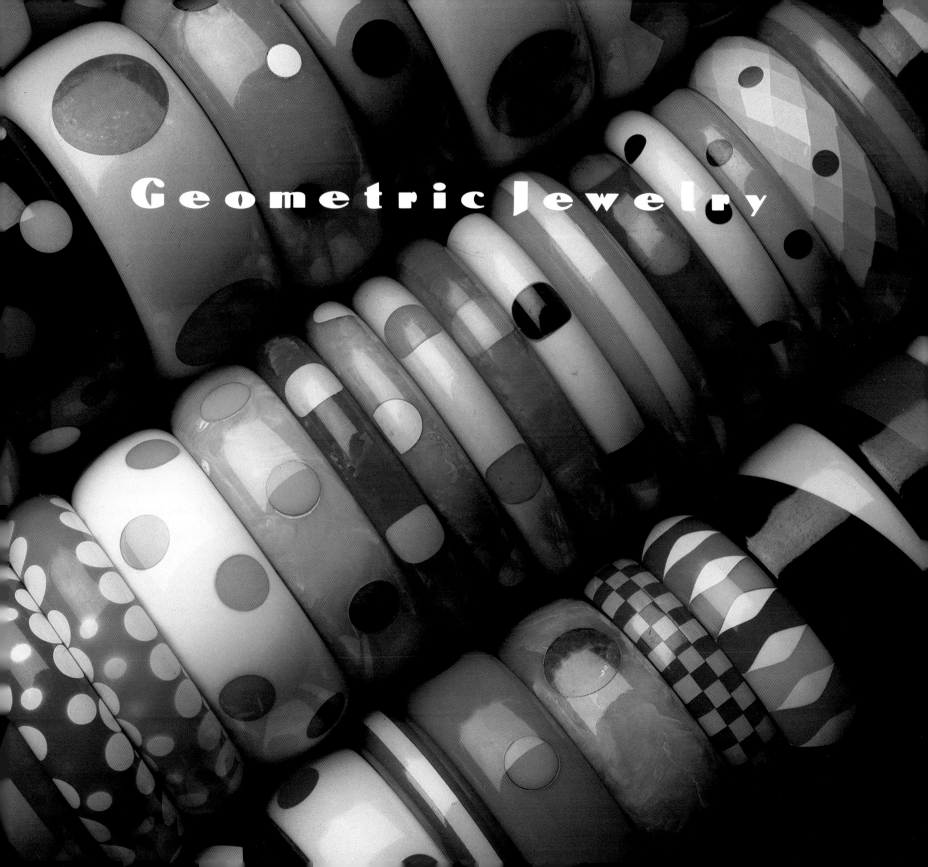

Geometric Jewelry

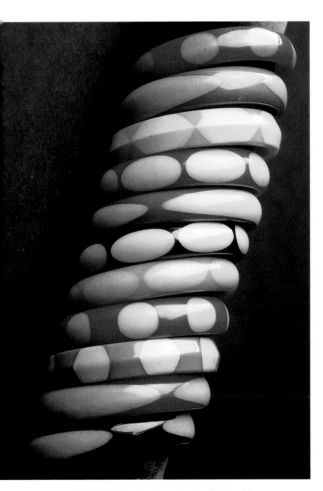

Bracelets designed by Belle Kogan.

nfluenced by the 1925 Paris Exposition's "Art Deco" designs and later by the streamlined "Art Moderne" movement, Bakelite jewelry paid its own tribute to the "Machine Age." In a profusion of rich, jewel-like tones, wonderful two-, three-, four-, and even six-color bracelets rolled across the jewelry counters of Europe and America. In designs that were spherical, linear, rectangular, triangular, and asymmetrical, in polka dots and stripes, in checkerboard and zigzag patterns, the thirties woman gaily proclaimed her sense of adventure and welcomed the changing times.

Geometrics fired the imagination of designers like France's Auguste Bonaz and New York's Belle Kogan. Belle designed a popular line of two-color jewelry with an original twist: polka dots that were elongated, or ovoid; in fact, dots that stretched as far as Belle's imagination (and the size of the bangle) would take them! While many pieces like Belle Kogan's dots sold for fifty cents in chain stores like Woolworth's, better department stores like Altman's and Bonwit Teller were selling more elaborate and intricately detailed pieces for as much as $3 (the price of a good dress!).

Today, the most-sought-after pieces of geometric jewelry are the bracelets. These were engineered in a variety of ways: the bangle, the stretchy (on elastic), the link, the cuff, and the hinged bracelet. Striped bracelets were laminated; that is, different colors of Bakelite were bonded (stripe to stripe) with a liquid phenolic resin glue, and then tumbled and polished as a single unit. The most fabulous of these laminated bracelets has been dubbed by today's collectors "The Philadelphia Brace-

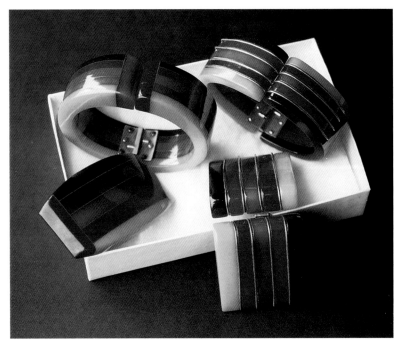

Laminated multicolor bracelets of the highest quality.

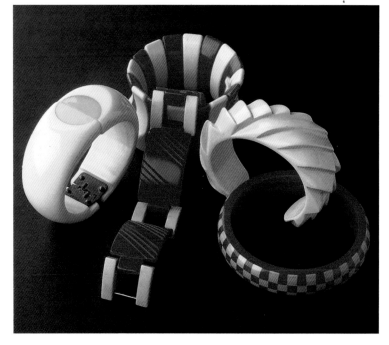

Five styles of bracelets made in the thirties.

let," because it was there two of them turned up at an Art Deco plastics show in 1984 and led to fierce competition. The Philadelphia piece is indeed splendidly fierce looking, with spiky multicolored "teeth" jutting from a heavy hinged bracelet. It sold for $250 then and is now worth more than $1,000.

Bakelite lovers are "dotty" about polka dot bracelets. These were made by inserting rods of one color into tubes of another, then slicing the tubes into bracelets, and, voilà! the sliced rods became dots.

Inserting the rods at an unusual angle caused a "bowtie" design to emerge when the bracelets were

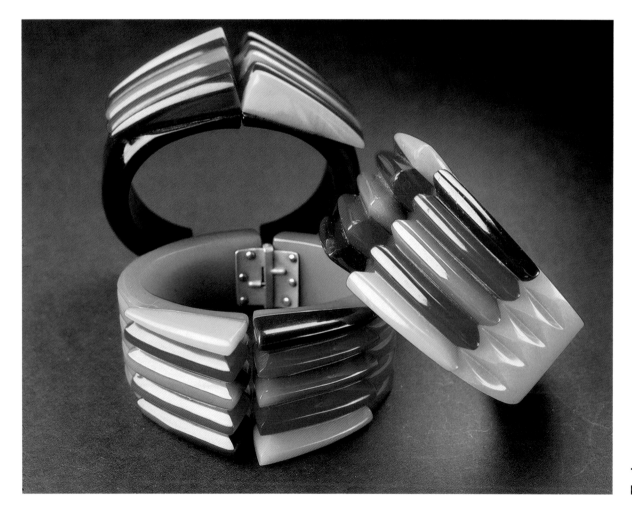

The infamous "Philadelphia Bracelets."

46

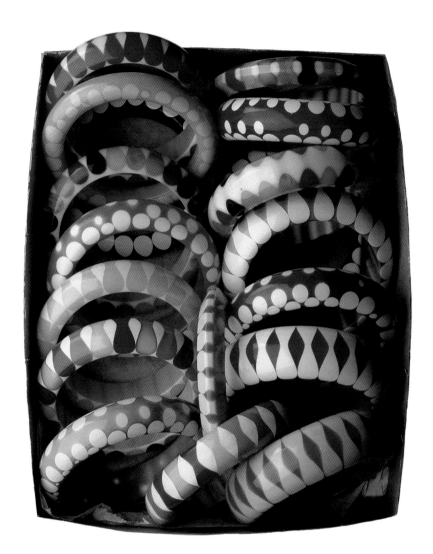

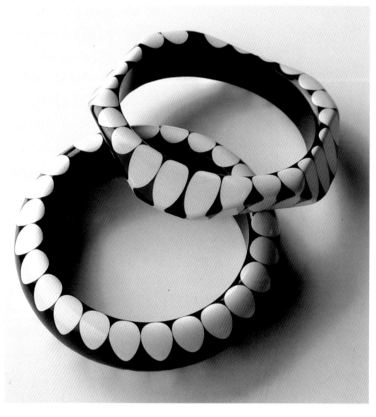

47

sliced. These bangles are particularly popular with collectors and are also known as "gumdrops" because the colors resemble nothing so much as a glorious box of candy: creamy creams, yellows and pinks, luscious reds, greens and purples. Although previously they were believed to be of thirties vintage, we recently discovered that the "bowtie" or "gumdrop" bracelets were designed and manufactured in the late fifties by Charles Elkaim, who owned a costume jewelry company in New York. Though not from the thirties, the bracelets are made of phenolic resin

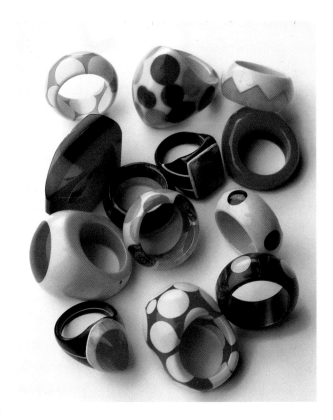

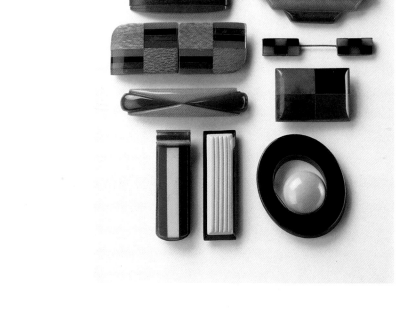

48

and are probably the last vestige of a nowadays-impractical manufacturing process.

Geometric rings mimicked in miniature the dotted and striped designs of the period, as did earrings, buttons, and dress clips. Laminated striped belt buckles and brooches abounded while bar pins decorated with wood or metal trim were

colorful classic fashion favorites.

Geometric necklaces are as much in tune with the times today as they were in the thirties. Besides strands of beads or pearls made of Bakelite, necklaces were commonly made with abstract pieces dangling from a cellulose acetate chain. Elongated "teeth," banana-sliced Os, and multicolored "logs" are some of the most fre-

quently encountered designs. Particularly fashionable were red-and-black and black-and-white motifs.

French designer Auguste Bonaz made stunning, sophisticated asymmetrical necklaces in Bakelite and Galalith. In the early seventies, a New York dealer discovered a cache of them in a tiny shop in Paris; old store stock, never worn, these signed

Geometric pins in typical Bakelite colors.

Geometric buttons and buckles with bracelet.

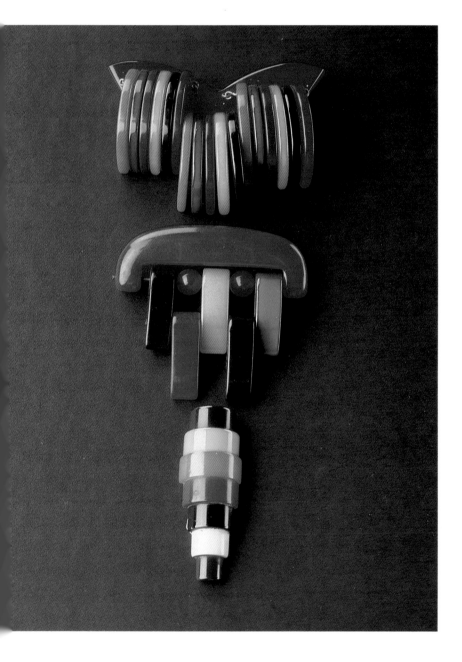

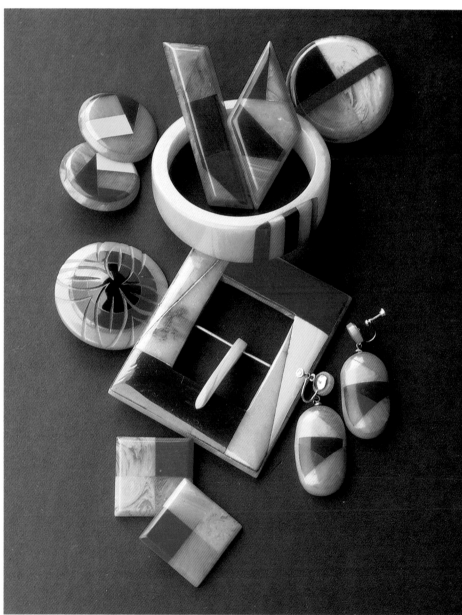

Classic geometric-style necklaces, and
matching pieces.

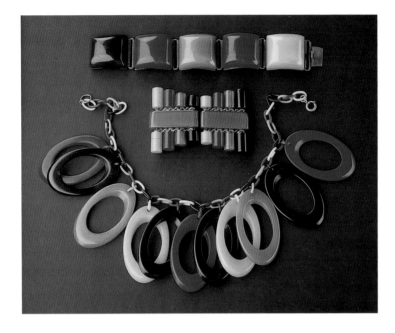 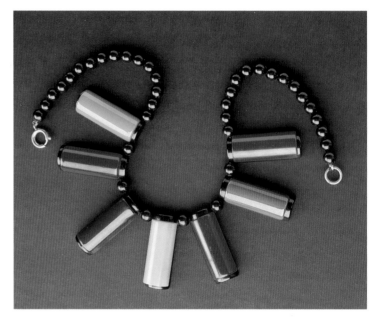

50

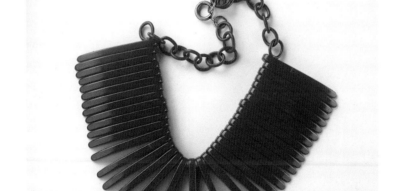

Red-and-black and white-and-black geometric jewelry.

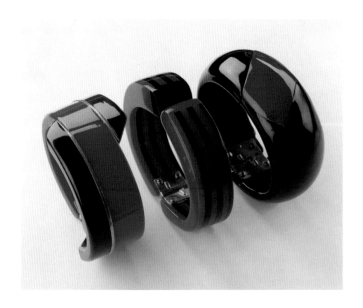

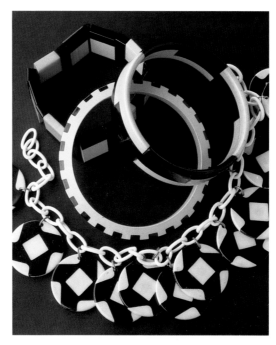

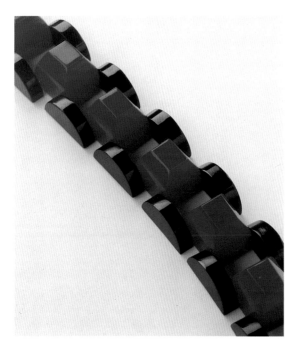

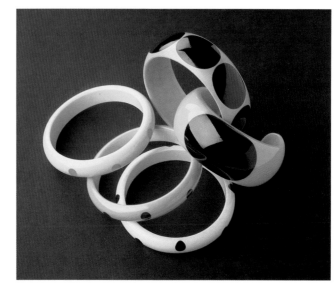

Necklaces made by Auguste Bonaz.

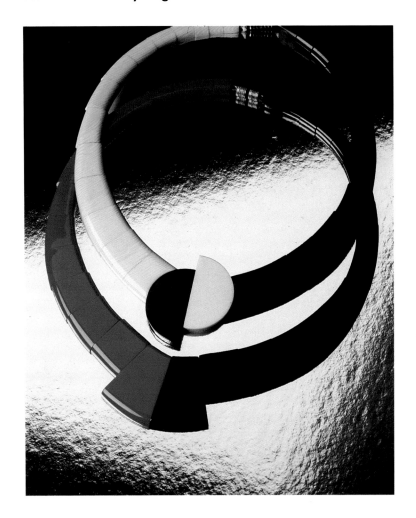

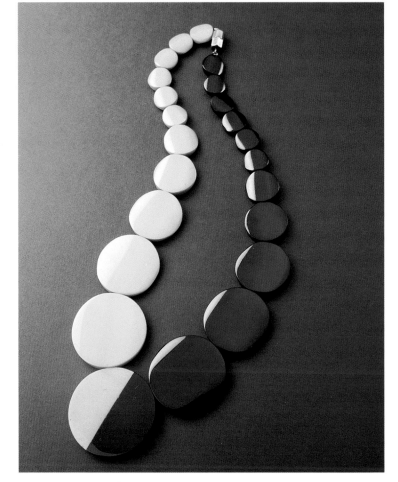

pieces are extremely valuable today.

Unlike the Bonaz pieces, most Bakelite jewelry, be it American or European, is not signed, and because of this, and the fact that there was very little written about the plastic jewelry of the thirties, it is difficult to trace the origin of most pieces. But we do know, for instance, that the combination of chrome or brass with Bakelite was much more popular with designers in France, Germany, and England than it was in America. If American Bakelite and metal jewelry often has a ratio of about six parts plastic to one part metal, then much European jewelry has that ratio reversed. Some of the most valuable European pieces use the plastic as a small, albeit fundamental, embellishment for the chrome, brass, silver, or gold-plate. Unlike its more playful American cousin, European Bakelite jewelry has a distinctly streamlined

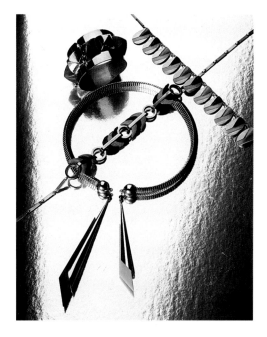

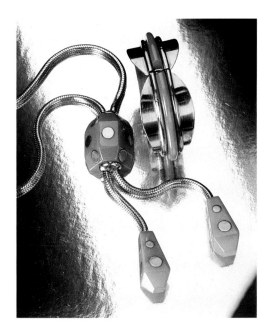

European chrome and Bakelite jewelry.

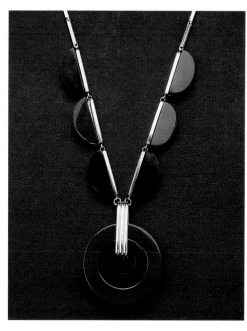

Delicate Bakelite and gold-plate necklace.

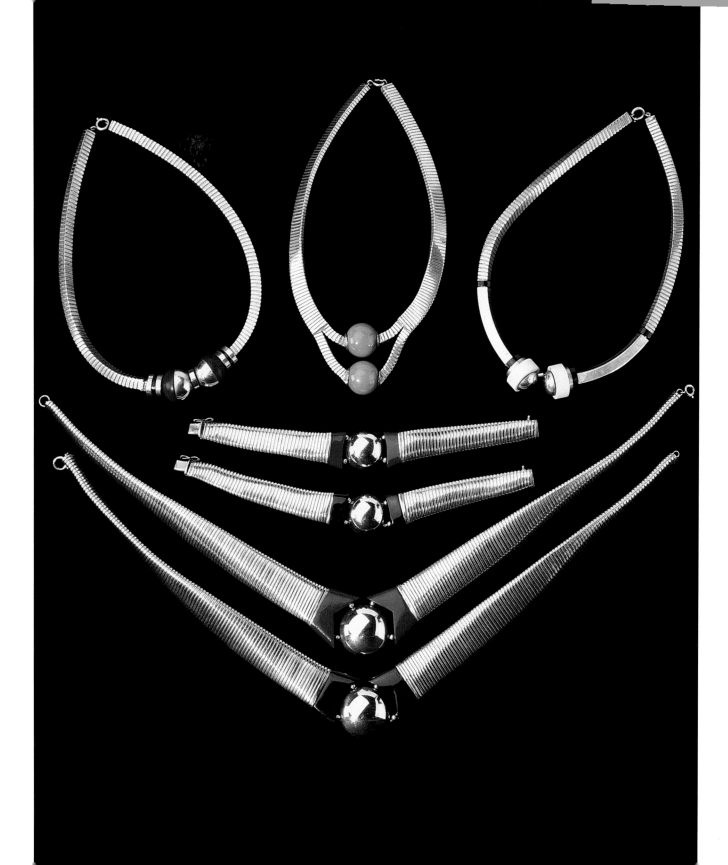

Chrome and Bakelite necklaces and
bracelets with German/Austrian
markings.

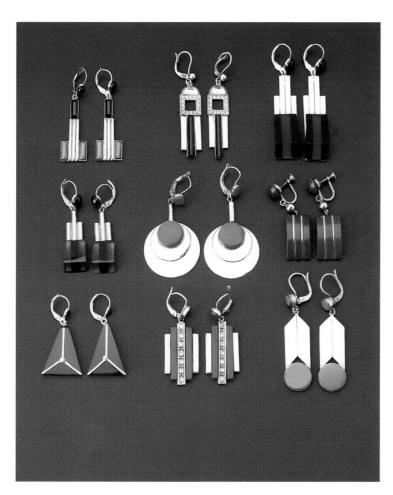

English and French Bakelite and
chrome earrings.

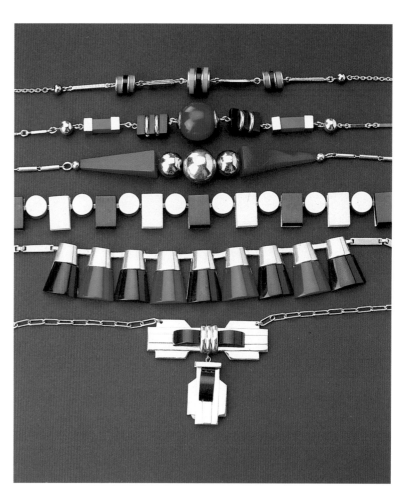

A selection of English, French, and
German necklaces.

Brass and Bakelite cuffs of French and English origin.

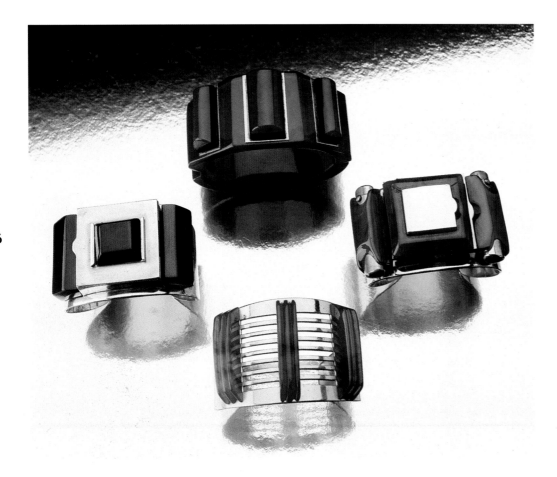

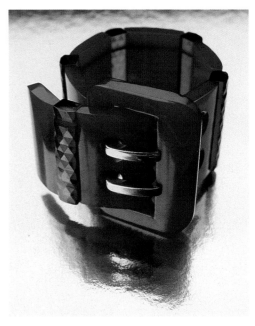

Exceptional English Bakelite and brass "belt" bracelet.

"Machine Age" look. *The Decorative Thirties,* a book by Martin Battersby, suggests that European designers had an "avant-garde obsession with machinery." Mechanical parts of certain designs that heretofore had been concealed, like screws and rivets, were now emphasized and celebrated.

From studying the vast amounts of jewelry obtained for this project, we saw certain patterns emerge and began to formulate rules of thumb for identifying the pedigree of an unsigned piece of jewelry. The English, for example, were extremely fond of combining Bakelite with brass in designs that were usually quite plain but impressively massive in look and feel. Germany brought forth the more austere "Machine Age" designs, usually in Bakelite and chrome. The pieces were, as a rule, not very large but always clean of line and flawlessly executed. French Bakelite jewelry, as one would suspect, was usually more sophisticated and, as well as brass and chrome, very often used rhinestones and pictorial designs. Engravings of harlequins, hot air balloons, "deco" women, and Pierrots are not unusual. A reporter for *Modern Plastics,* Grace Young, upon viewing French plastic jewelry at a plastics exhibition in Paris in 1939, had this to say: "The

Signed Mexican silver and Bakelite hinged bracelets.

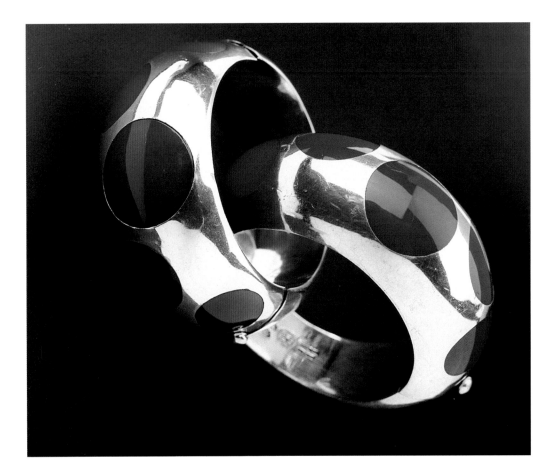

57

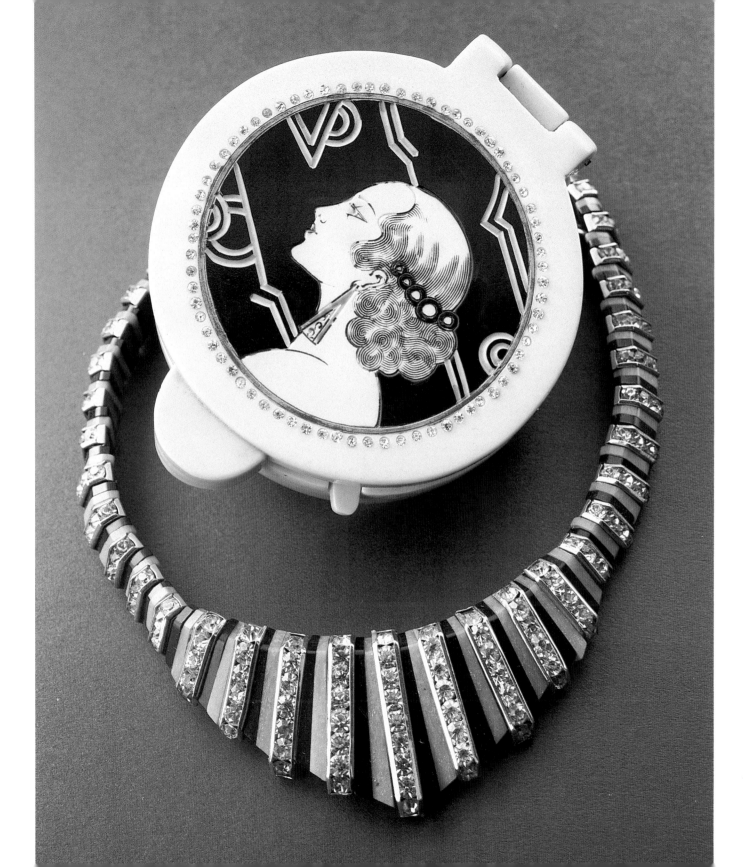

French Bakelite and rhinestone necklace and compact.

mysterious ingredient that makes French plastic jewelry so right . . . and makes women exclaim 'Oh, it looks very French!' . . . is femininity's genuine tribute to French authority in design, patience in workmanship and everlasting romanticism.''

Some of the most elaborate pieces of European Bakelite jewelry we have ever come across boast a special provenance. These were the bracelets commissioned by the internationally famous exotic dancer and singer Josephine Baker, as presents for her dearest friends and fans. Some of them incorporated compacts with miniature lipsticks, powders, and mirrors into their design. The most bizarre of them combines Bakelite with genuine peacock feathers!

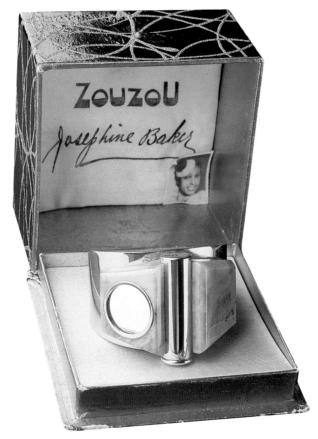

Lipstick and powder cuff made of Bakelite and brass, a Christmas present from Josephine Baker to special friends.

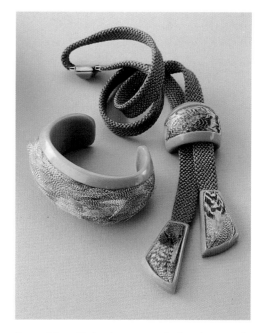

59

Josephine Baker's peacock feather and Bakelite bola and cuff.

Transparent and translucent Bakelite jewelry was also very much in demand in the thirties and forties. Some of these pieces were dyed striking colors and faceted to look more jewel-like. Some were adorned with colorful, opaque, geometric shapes. Still others were set with imitation precious stones or pearls made of Bakelite. In her definitive book, *Art Plastic,* Andrea DiNoto shows a Bakelite bangle set with an entire circlet of diamonds. But this, she suggests, was an anomaly—perhaps owned by some devil-may-care heiress!

60

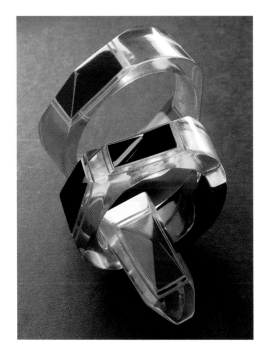

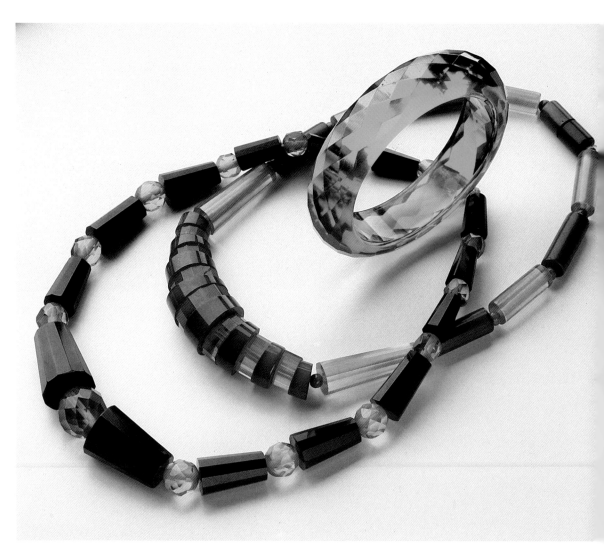

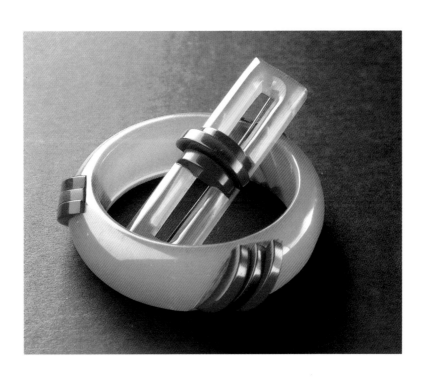

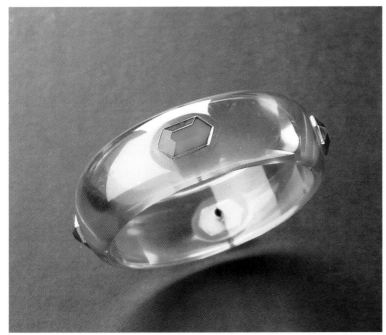

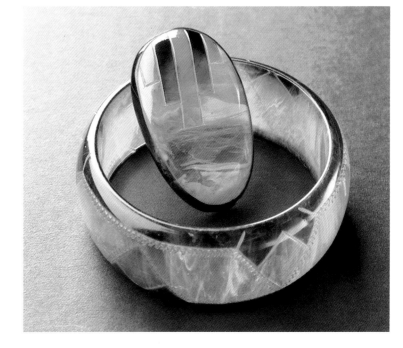

Finally, a word about Bakelite's color range. The most common colors: red, yellow, green, maroon, and black were just about the only colors made in the thirties that time and sunlight did not change. In 1934, the Catalin Corporation boasted a palette of more than two hundred colors. Where did they go? A Bakelite collector we know set up a home workshop, took to refinishing old pieces with sandpaper, and astonished everyone with the colors found trapped beneath the surface. There, a few layers down, were all the pastels, all the nuances of shading that had been missing. Underneath that cream: a white-white. Underneath that brown: lavender! All those red, cream, and black necklaces: red, white, and blue. And that murky green and orange bracelet? *Miami Vice*'s very own turquoise and pink!

It must be pointed out, however, that, in many cases, the color changes brought about by time have actually *improved* the look and desirability of a piece, much like the patina on a fine antique.

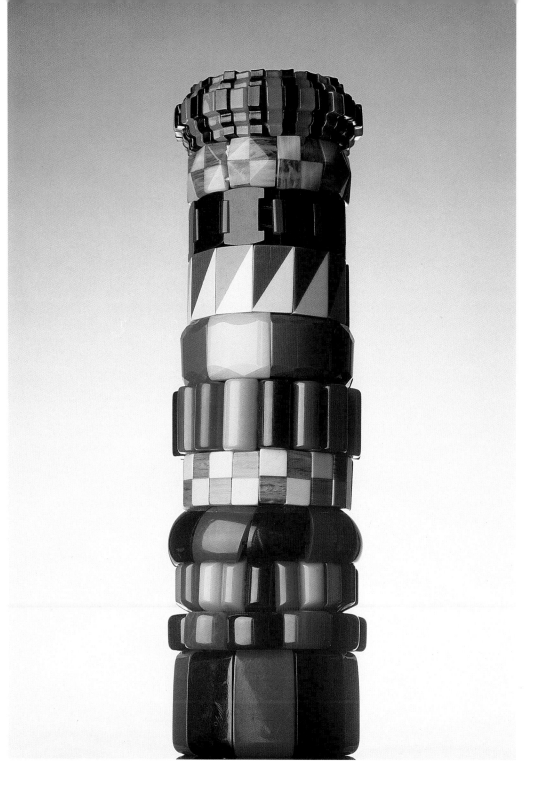

Geometric "stretch" bracelets.

Refinished dot bracelets.

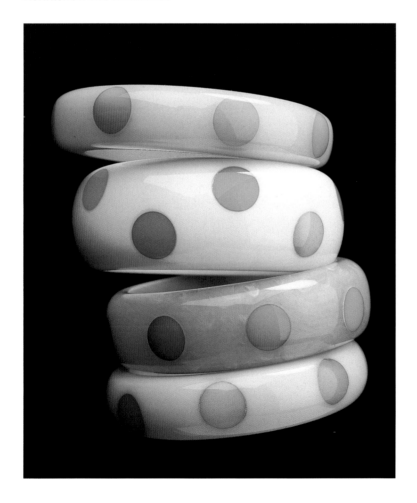

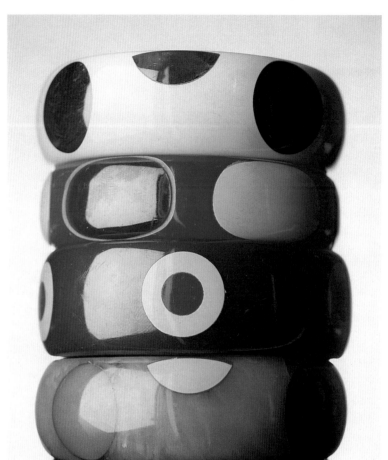

63

Dot bracelets with rich patina.

Of all the objects made of Bakelite in the thirties and forties, the category most closely associated with the jewelry would undoubtedly be that of jewelry boxes, vanity jars, and powder boxes. They came in an imaginative variety of shapes and sizes and in designs that were architecturally impressive, making the vanity top of the thirties woman a lively array of color and form. Not only toilet articles but cosmetics such as lipstick and rouge were packaged in reusable plastic containers. Bakelite was the perfect material to house toiletries and perfumes that contained alcohol, since it could not be harmed by organic solvents.

Cigarette smoking, which was utterly glamorous in the thirties, inspired the production of countless boxes that could be used for either cigarettes or jewelry. The designs of these boxes were inexhaustible—they were rectangular, square, circular, oval, stepped, scalloped, fluted, be-footed, and carved.

French designer Auguste Bonaz, who today is known among collectors almost exclusively for his Bake-lite and Galalith jewelry, was actually, first and foremost, a designer of powder boxes and haircombs. Ads for his toilet articles can be seen in early issues of *Les Echos d'Art*, a French magazine from the thirties celebrating the Art Deco style. His combs and boxes can now be viewed at the Musée du Piegnes et des Matières Plastiques in Oyonnax, France.

Especially decorative were the vanity sets, desk sets, and smoking sets signed "Carvacraft" and sold in such London department stores as John Dickinson and Son in 1940.

Today there are many collectors of Bakelite who specialize in the boxes, be they jewelry, powder, or cigarette. The high point of one collector's box collection is a beautiful round, clear-yellow powder box with a floral motif carved into the reverse side of the top. Just recently, in the *Plastics Catalog of 1942*, we discovered that this box was but one piece of an entire makeup and toiletry line called "Desert Flower" that the Shulton Company produced. It was much admired in 1942, winning first place in a design contest for its packaging

and for "bringing recognition to the creative genius of the designer and tribute to the beauty, color and interpretive power of Catalin."

Many boxes with imaginative touches were the work of home crafts-people who in the thirties and forties purchased hobby kits designed by such prominent industrial designers as Roger Woolcott. Ads can be found in old issues of *Popular Mechanics* and *Home Craftsman* for companies such as Trafford Modern Materials and the Fanwood Specialties Company, who would send their customers a selection of tubes, rings, and square and rectangular sheets of Catalin, "the perfect workshop material," plus glue, a small hacksaw, and whatever findings were necessary. The book *Plastics in the School and Home Workshop*, written by A. J. Lockrey and published in 1940, reported that "most plastics companies sell cast box forms (four sides and the bottom complete); making a box with these consists of merely making and fitting the top and the ornamentation." An easy-enough job for something so lovely to look at!

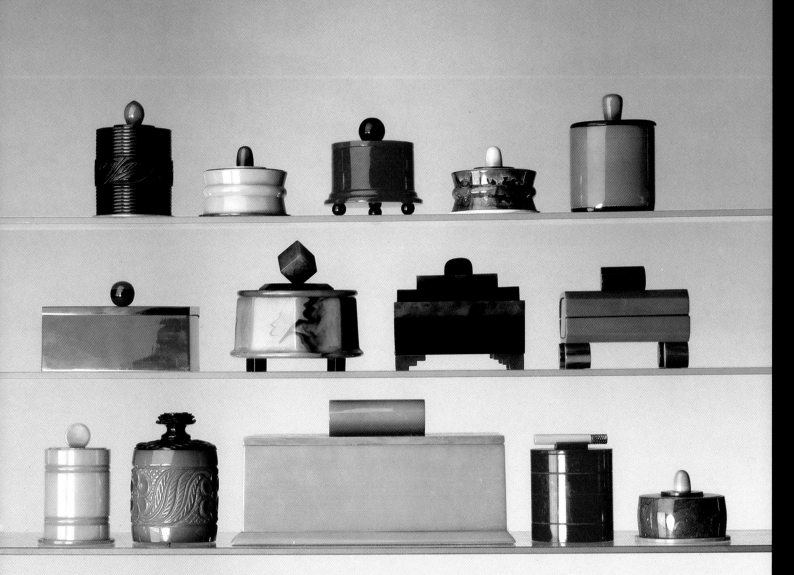

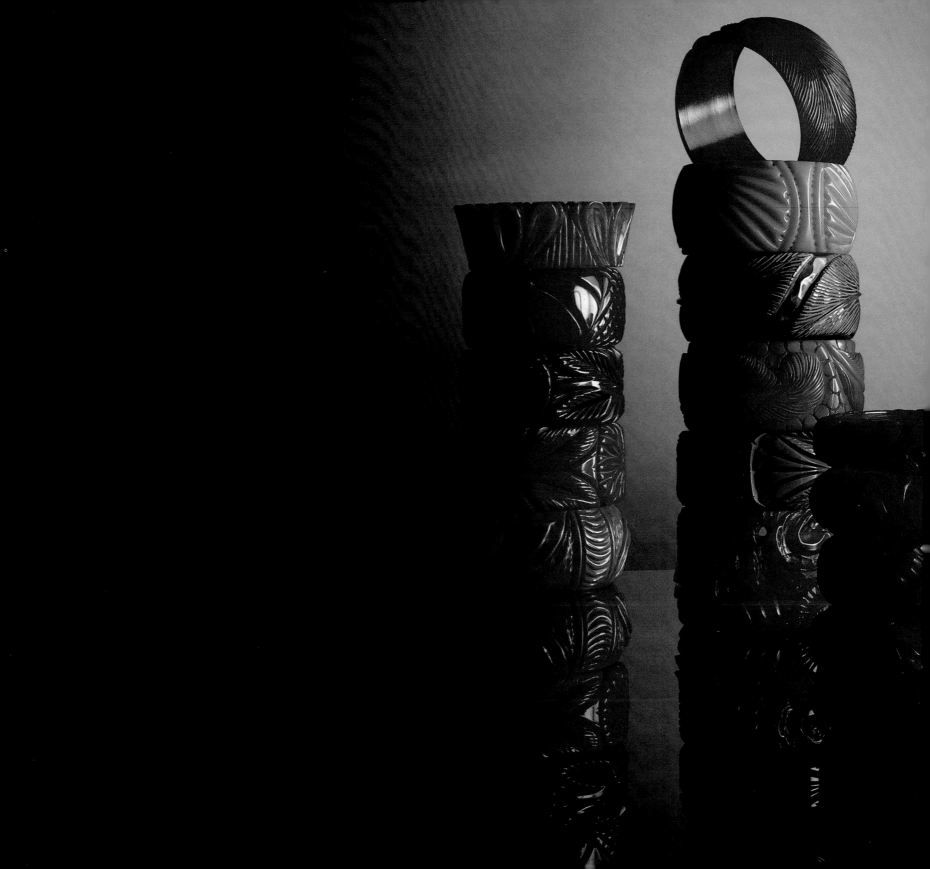

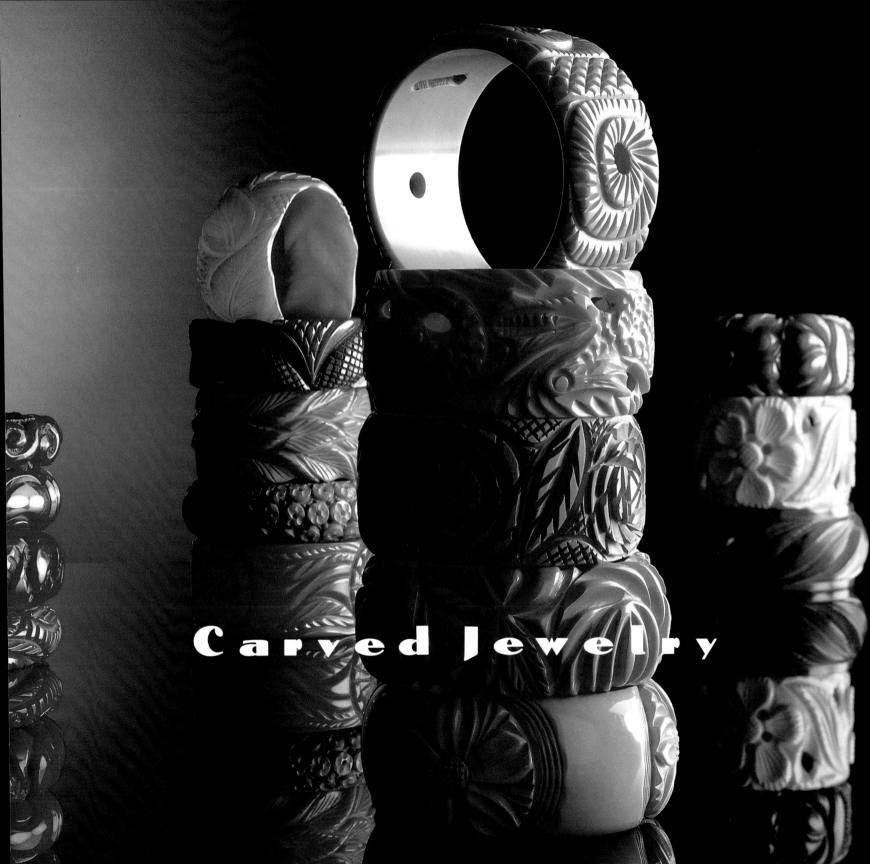

Carved Jewelry

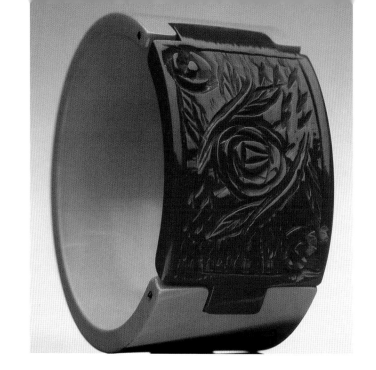

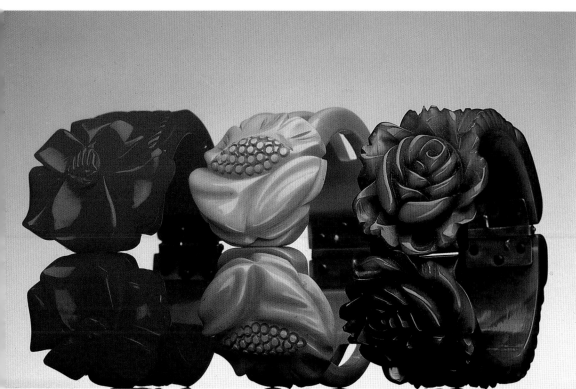

here is no sound on earth quite like the "click"—no, the "clack"—no, the "clunk"—of two carved Bakelite bracelets knocking together on the arm of a Bakelite-jewelry lover! Described as "fashionably bulky" by the trade magazine *Modern Plastics,* carved bracelets were by far the heftiest and clunkiest of all Bakelite jewelry. They were generally larger and thicker to accommodate the deep hand-carving that distinguishes them from the rest of the cast phenolics. Carved pieces contrast dramatically with their streamlined, machine-age counterparts—they are fanciful, romantic, adventurous, and ornate. Jewelry manufacturers originally intended Bakelite to imitate more expensive materials like ivory, onyx, coral, jade, and amber, but soon they fell sway to Bakelite's own unique seductiveness, its color and texture, its "plasticness." Hence, cinnabar gave way to lipstick-red, ivory to butterscotch, jade to a greener green.

All the carving was done by machinists who hand-held their work against lathes with high-speed carving spindles attached. They memorized the cuts (the strokes that made up the pattern), centered their designs by eye, and proceeded with extraordinary skill and speed to carve the designs on the blank. They carved the deeper cuts first, taking care not to go too deep and weaken the piece, and then the shallower cuts. On especially complex pieces, the work was passed assembly-line style from one operator to the next, each using a particular cutter for a particular part of the design. Since each carved piece was finished by hand, no two were ever exactly alike.

Because of the high luster of Bakelite once polished, the finished carving tends to look more intricate than it actually is. While less-detailed pieces were tumble-polished, deeply carved ones were usually "ashed"— that is, polished with wet pumice against a muslin wheel and then

69

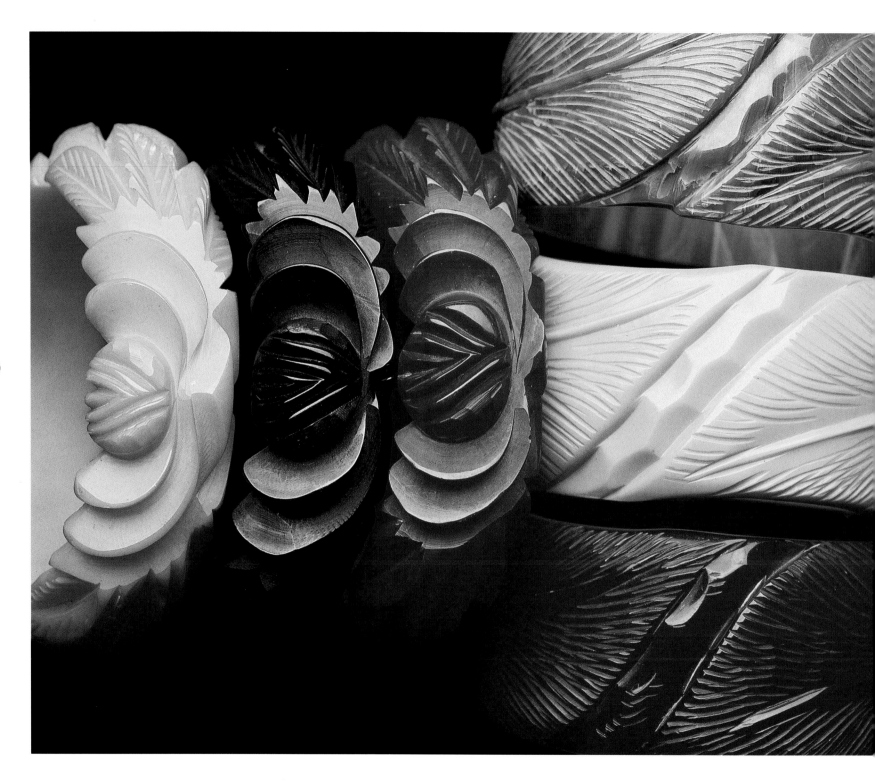

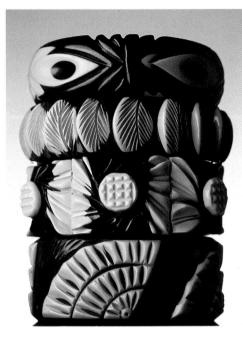

"Totem pole" of cast two-tone bracelets.

waxed with a polishing compound against a dry muslin wheel. A quote from an article in *Modern Plastics* illustrates exactly how seriously the entire jewelry-making process was taken: "These materials of rich deep colorings may be enhanced or *profaned* at the hands of the workmen who convert them into consumer goods." (Italics added)

The technique of two-tone casting (the core of one color inside the shell of another) was used to interesting effect in carved figural and abstract pieces. For instance, when a core of black Bakelite was cast with a yellow shell and carved, the machinist's tool would cut through the yellow into the black, producing an arresting topography, with peaks of yellow and valleys of black. This added dimension could be even further enhanced by selective polishing of only the peaks, leaving the valleys raw or frosted. This technique (not confined to two-tone pieces) caused the carving to virtually pop out.

Rare figural two-tone "dice" bracelet.

71

A material that many carvers used was called "end-of-day" Bakelite. This consisted of all the remnants of colors made in a factory on a given day poured into the same mold. Also called "jazz" or "variegated," it was usually sold at a discount by the factories, and jewelry makers liked it for its unusual color patterns reminiscent of the marbleized endpapers of fine old books.

The inlaying of metal into plastic became popular in the mid-thirties, and nowhere was it used to greater advantage than with pieces of carved Bakelite. Before that time, decorative metal was either screwed or cemented into place. But with the discovery of a new technique, the grooves in carved plastic pieces could be filled with molten silver- or gold-colored "liquid" metal that was poured at a lukewarm temperature (so as not to scorch the plastic), allowed to harden, and then polished and finished all of a piece. The fish bracelet pictured here is an extraordinary example of metal inlay; every

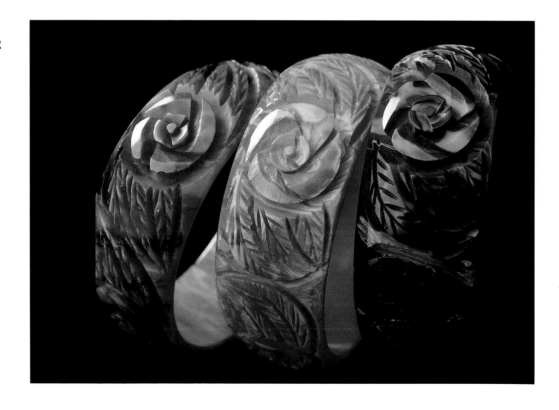

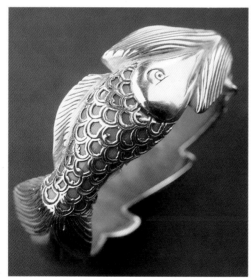

"End-of-day" bracelets.

Deeply carved "leaves" bangles.

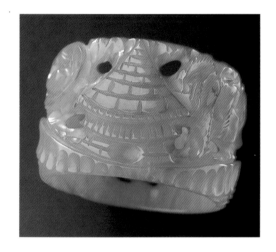

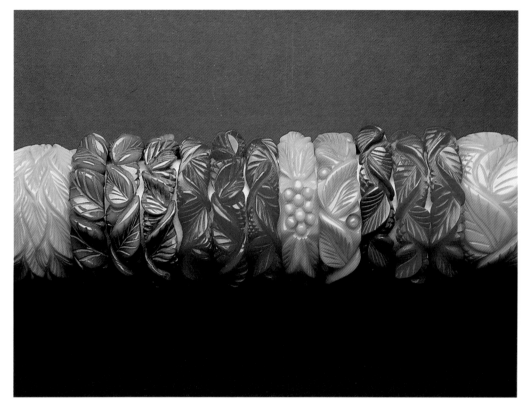

gill, fin, and scale precisely highlighted.

The return to naturalism in the thirties inspired the most beautiful of the carved bracelets: those that incorporated the flora and fauna of the South Pacific, Africa, and the Orient. The designs featuring high relief berries and deeply carved leaves are a great favorite with collectors. The carvers imitated art from Gauguin to Van Gogh. Certain rare (if not one of a kind) bracelets tickle the imagination with their ambitiousness.

Here, one tells a complete story: an idyll of flowers and clouds, a road leading to a bridge, a bridge leading to—a pagoda, no less! Animals, real and fantastic, were another attractive topic. Besides horses, birds, fish, and dogs, the manufacturers and (we can assume) the consumers seemed to favor all things slimy and reptilian: frogs, crabs, turtles, mudpuppies, lobsters, serpents, dragons, and lizards. Florals were another perennial favorite with collectors.

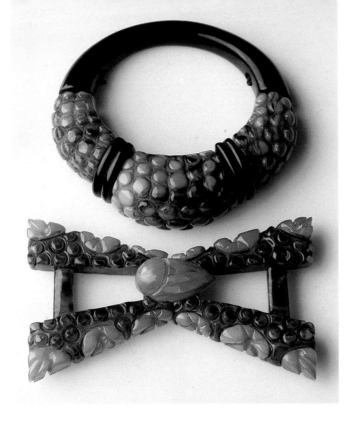

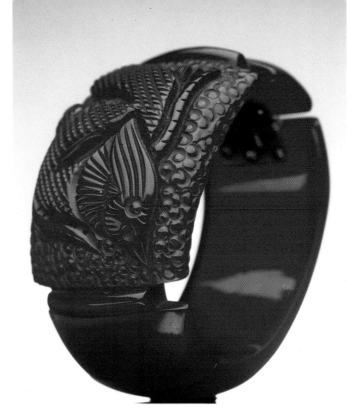

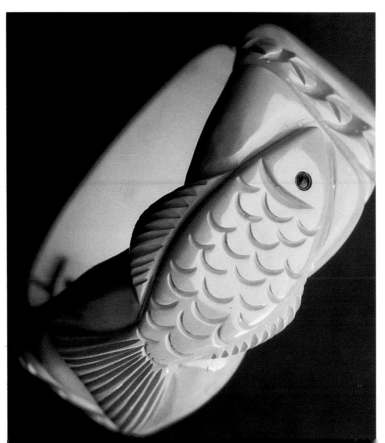

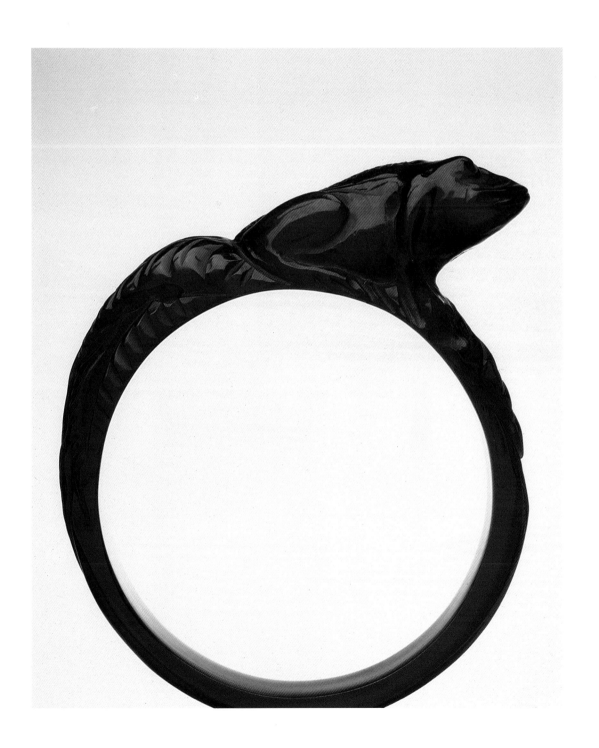

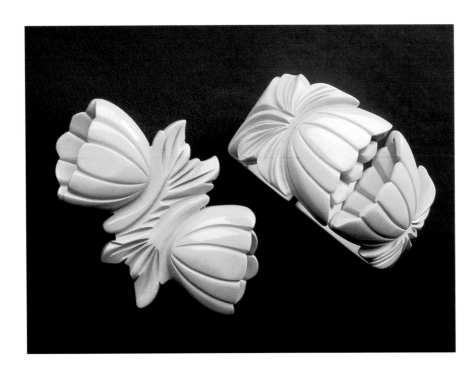

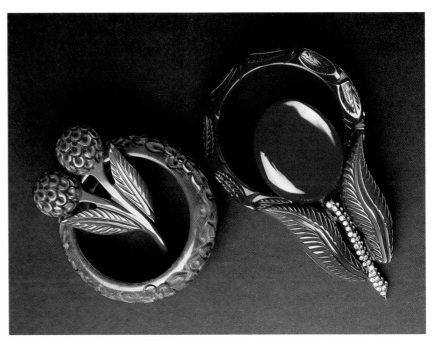

Floral bracelet and pin sets.

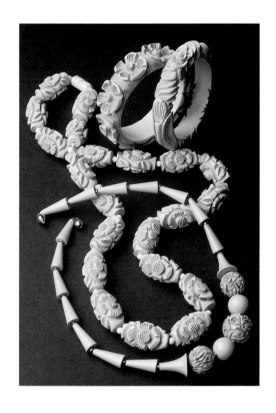

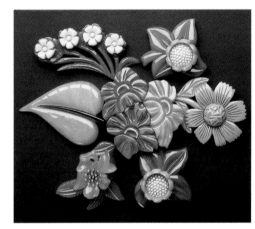

A bouquet of Bakelite flower pins, necklaces, and bracelets.

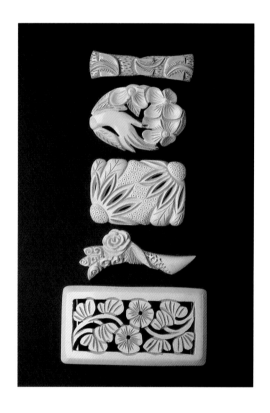

It remains a dream of the ardent collector to find a complete original set manufactured during the thirties, but the chance of finding it all in one place is highly unlikely. Collectors wait years to marry the matching brooch to their favorite bracelet. For some, acquiring all the colors in a particular pattern is the ultimate challenge.

Notable in the design and fabrication of carved plastic jewelry were the Ace Plastic Novelty Corporation of Brooklyn, New York, and the Alta Novelty Company of Manhattan. They each designed exclusive product

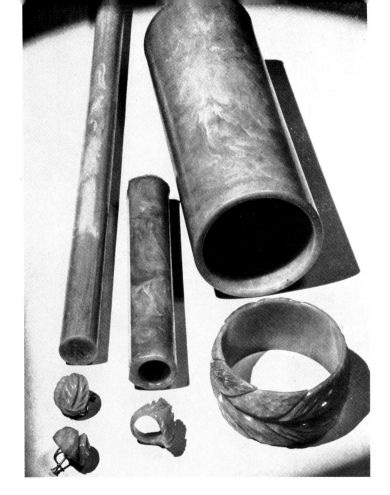

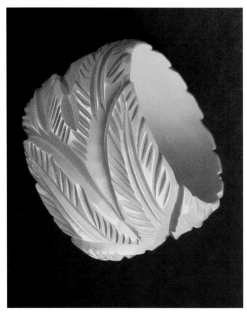

A photo from *Modern Plastics* illustrating the stages of development of Ace Novelty's giant leaf bracelet made of "real Marblette."

Giant leaf bracelet.

lines that were sold in high-priced Fifth Avenue department stores. Ace Novelty was known for its wonderful tropical and Hawaiian-esque designs, guaranteed to make even the most sedate collector start humming "Lovely Hula Hands."

Alta Novelty was a family-owned-and-run business that produced goods of top quality from 1931 to 1941. Ten members of the Mouré family turned out some of the more imaginative carved, figural, and geometric jewelry of the thirties. Today Roger Mouré, in his mid-sixties, and his brother Rod, in his mid-seventies, reminisce about their "Catalin and Wood Ornament" business. They sold their bracelets for approximately $84 a gross, or $7 a dozen, and informed us that design pilfering was their biggest problem. As soon as they came up with an innovative new design and sold it to one of their department-store clients, there would be knock-offs of it all over New York within a matter of days.

We had assumed that all Bakelite had been mass-produced, probably thousands of pieces at a time, but the Mouré Brothers surprised us with the fact that when it came to Alta's expensive top-of-the-line pieces, only six to twelve of any item were made, unless it was a runaway best-seller.

No wonder there are so few really exceptional examples of Bakelite jewelry left today; there were never too many to start with!

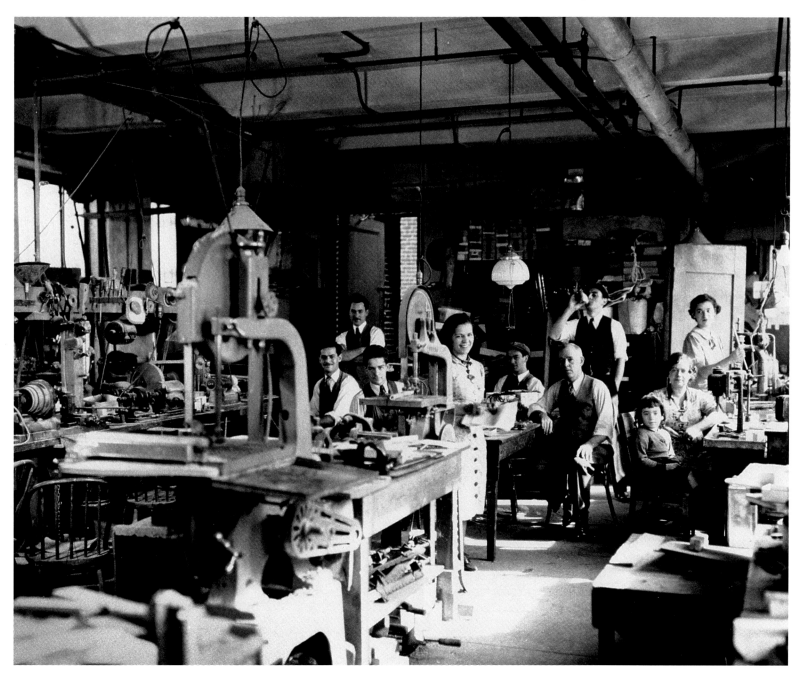

Alta Novelty's Mouré Family at work.

Beautifully carved "strawberry" set.

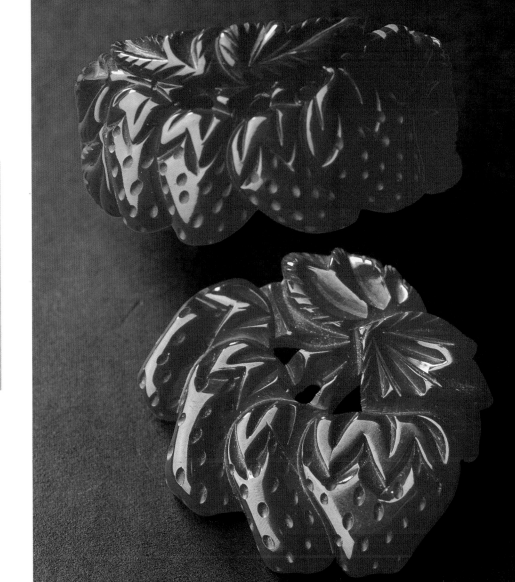

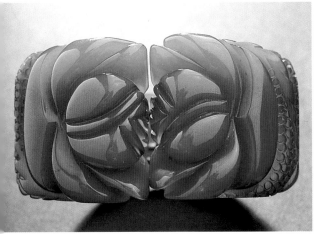

Hail Britannia

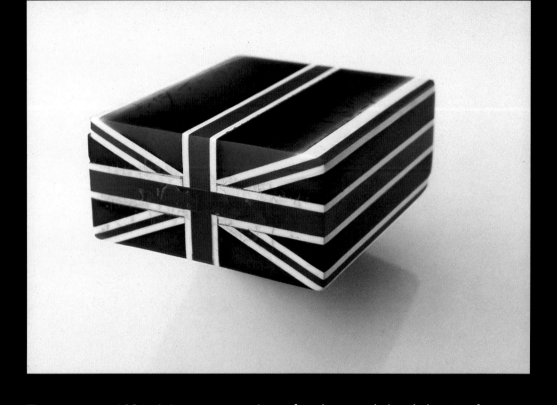

The year was 1936. A historic year if ever there was one. The world had "Royalty" fever. With the impending coronation of King Edward VIII, the New York department store Lord & Taylor called upon Alta Novelty to produce a Union Jack pin to celebrate the event. Roger Mouré recalls that it was a very difficult job, each red, white, and blue piece having to fit perfectly and to be laminated at exactly the correct angle. The Mouré family made a block (the end of which is pictured above) over two feet long, and sliced the pins from the block, each of them about an eighth of an inch thick. Lord & Taylor did very well with their order and completely sold out.

The year was still 1936. For the love of Wallis Simpson, King Edward abdicated the throne and King George VI was yet to be crowned. Lord & Taylor, not about to miss a sales opportunity, called Alta Novelty: "Have any more Union Jack pins?"

Alta took out the remainder of the block and started slicing.

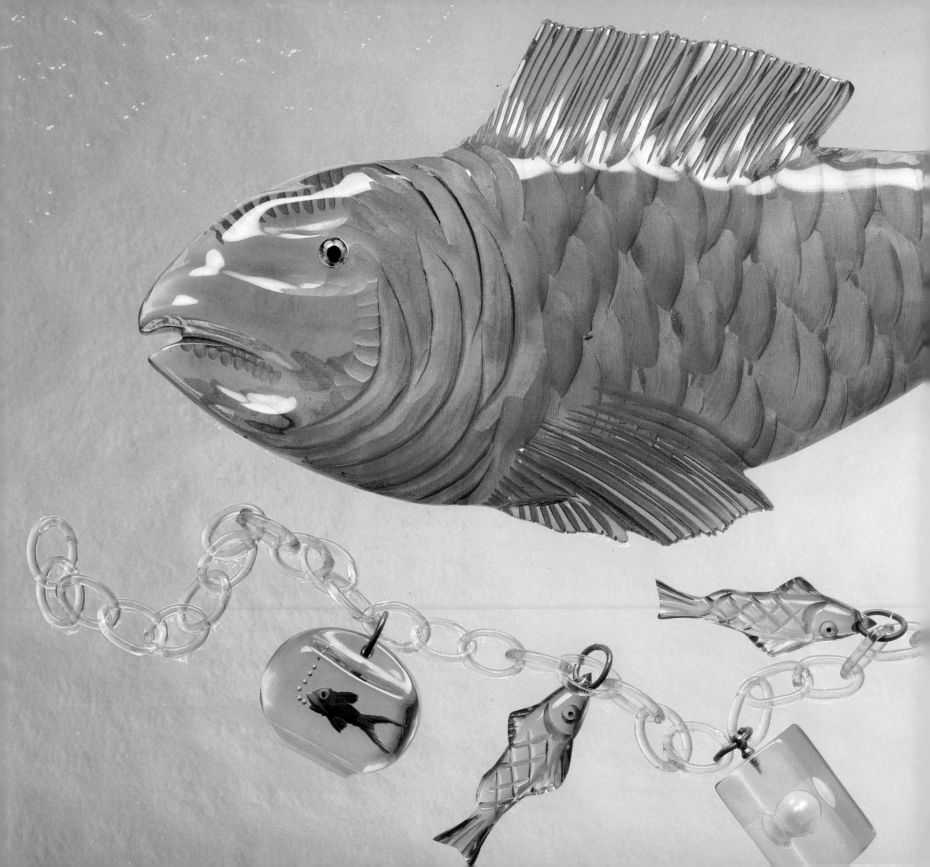

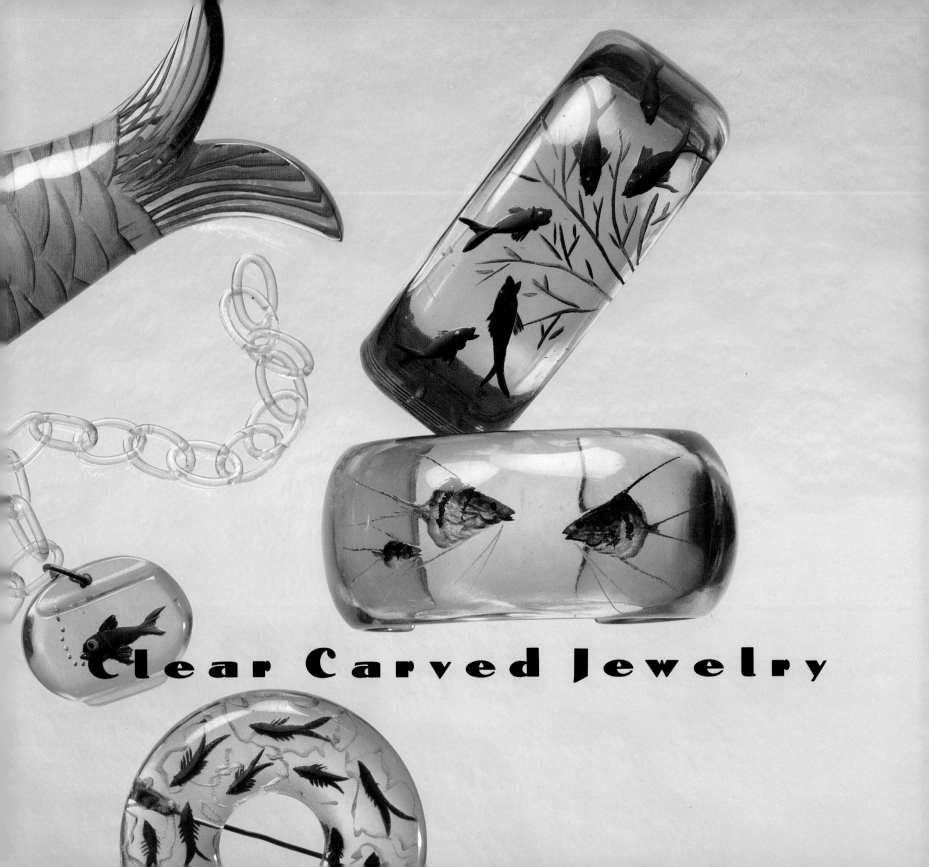

Clear Carved Jewelry

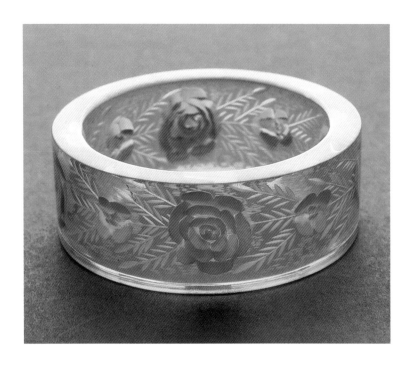

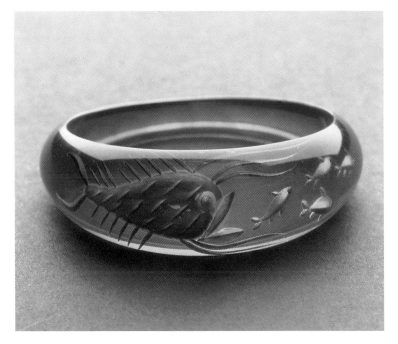

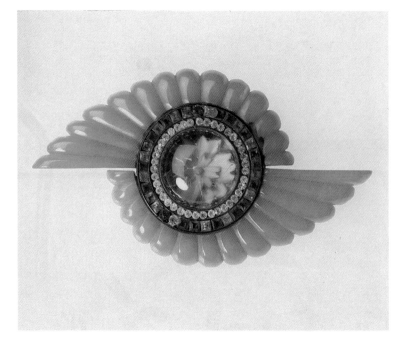

"The effect of coral as seen from a glass bottom boat."

"Like a flower or other object frozen into a block of ice."

"The brilliance of crystal acting like a magnifying glass."

these were some of the ways writers in the thirties described reverse-carved jewelry, the most unusual of all Bakelite jewelry. This technique was also called "under-carving," because it was done on the underside of a piece of transparent cast resin; the depth of carving showed up as height when viewed from above, and the optical perspective changed from every angle.

Depending on whether the maker was a home craftsman or a skilled machinist, pigment was either painted or injected into the carving. The result: a glorious fishbowl of color, a three-dimensional flower garden as pretty as any paperweight but so much lighter.

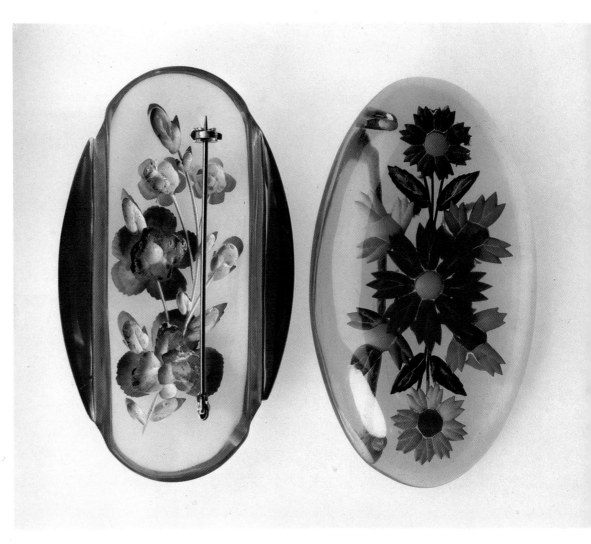

Two reverse-carved pins, one showing the carved and painted underside.

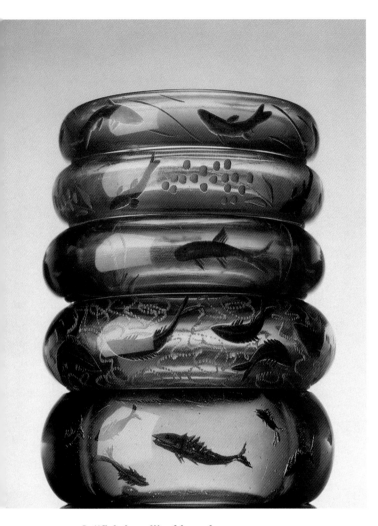

A "fish bowl" of bangles.

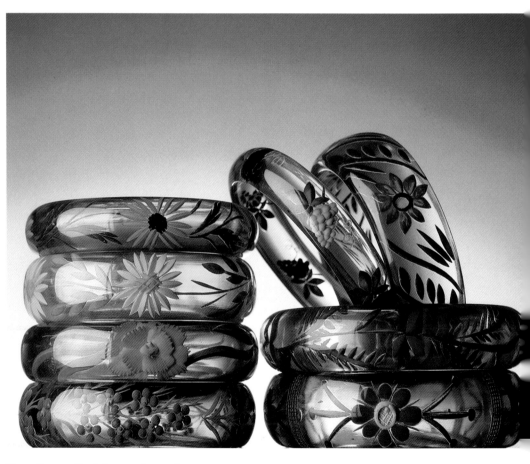

Two "vases" of flower bracelets.

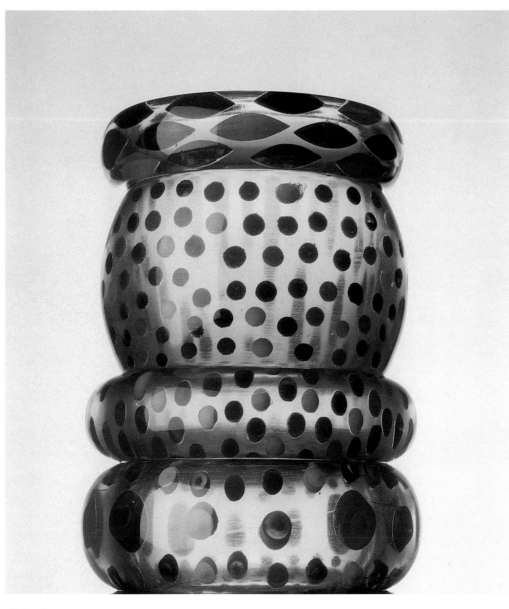

Colorful painted dot bracelets.

Clear cast phenolics were first intended to imitate crystal, and one of the selling points was "the beauty of crystal at a third of the weight." Clear carved jewelry looks nothing like the opaque variety, but it was born of the same creative essence and love of color. Virtually no serious collector of Bakelite jewelry is without at least one wonderful example of this technique.

Transparent cast resins were 15 to 20 percent more expensive than opaque raw materials, and with the added labor of both carving and dyeing the piece, reverse-carved jewelry found itself at the high end of the thirties price spectrum. Most often seen today are intricate floral designs with pansies, daisies, and buttercups so lifelike it is hard to believe they are not actually real flowers imbedded in plastic. Aquatic motifs were also perfectly suited to the medium —the transparent plastic provided the fishbowl in which beautiful fish might swim! Geometric designs with cross-hatching, parallel lines, and concentric circles also took on a completely new look when they were undercarved: the plastic gave the design an optical illusion of texture or weaving.

While some of it was tinted or

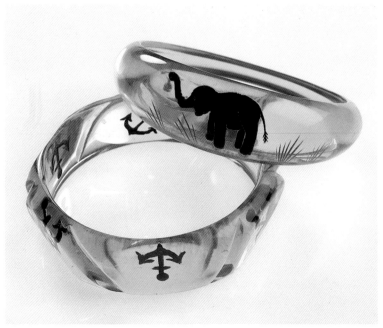

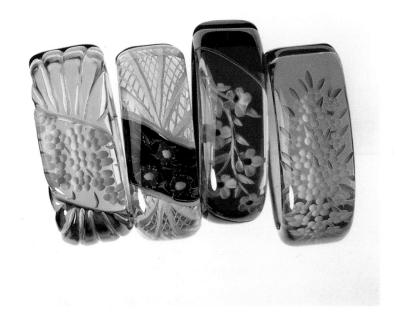

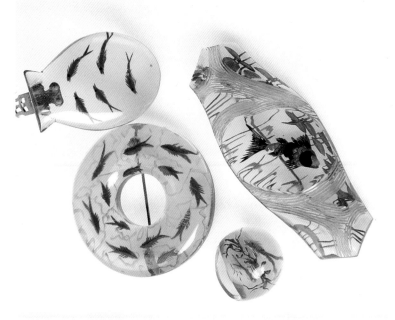

Striking geometric reverse-carved bracelets.

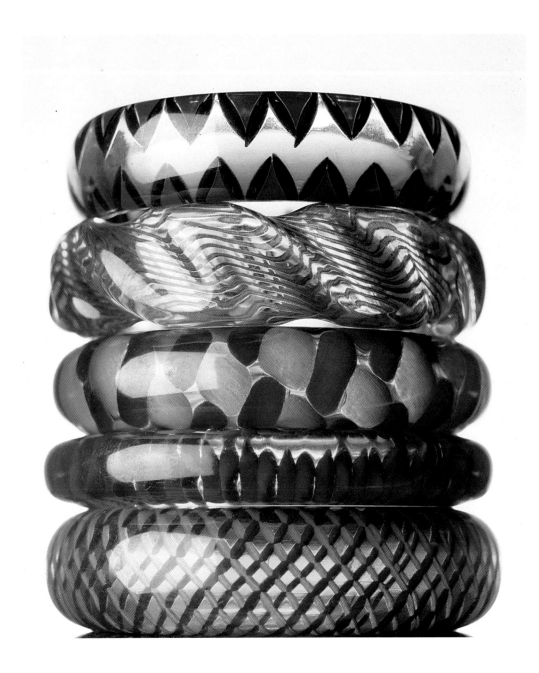

dyed, most of the clear cast resin was left clear or "water-white" (which over the years had a tendency to turn a pale yellow). Often it was laminated to opaque Bakelite, thereby supplying a kind of frame for the "painting." Today, necklaces and rings are rare, but bracelets, pins, and clips can still be found.

The Catalin Corporation, the forerunner in decorative uses of cast phenolics, introduced clear jewelry to the public in 1935 under the name of "Prystal" (an acronym for plastic and crystal), after purchasing the rights to

Undercarved "paintings" framed in Bakelite.

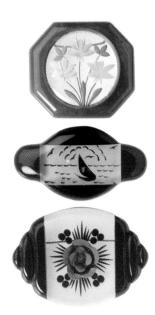

this trade name and formula from the Société Nobel Française. In the June 1935 issue of *Modern Plastics,* an article on Catalin reported that the French variety of Prystal had a "susceptibility to cracking and distortion under varying changes in temperature and atmospheric conditions." The Catalin Corporation apparently felt it had worked out all the problems with this formula, but today the cracking and distortion of clear carved jewelry is an ever-looming threat to collectors. Although a rare occurrence, almost every collector

we know has lost a piece or two to the instability of Prystal. The Mouré Brothers shed a somewhat ominous light on the subject, explaining that because of heat, light, and lack of humidity, "it's all gonna go sooner or later." So, it might be added, are we!

By 1940 clear cast phenolics were joined by the new kids on the block: Plexiglas and Lucite, and although they were worked in the same way, these acrylic resins did not have the rich allure of Catalin and Prystal. There was only one "Gemstone of Modern Industry."

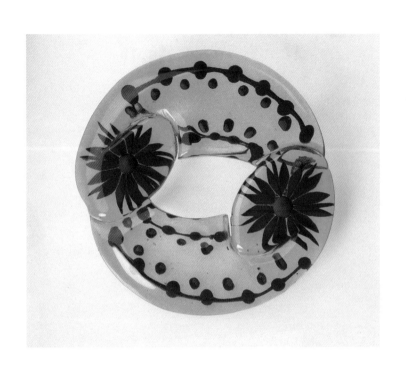

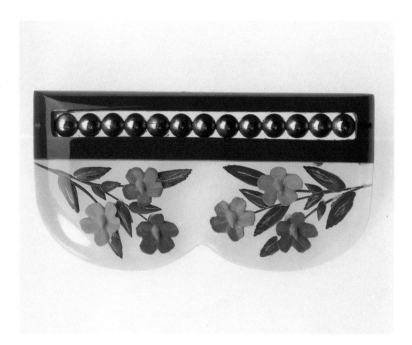

91

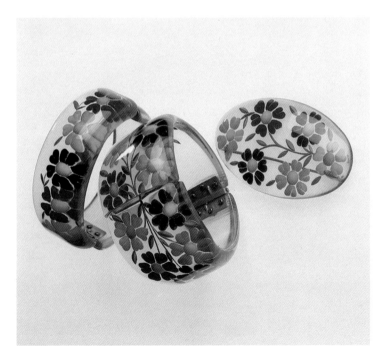

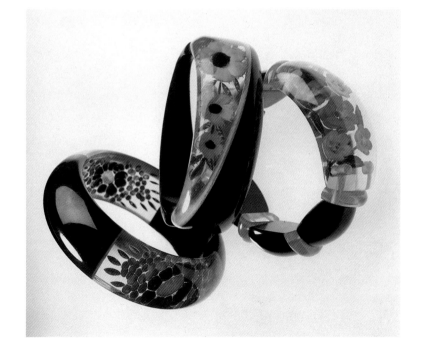

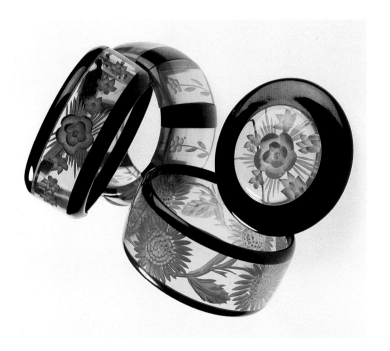

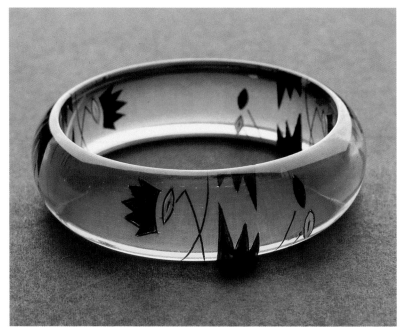

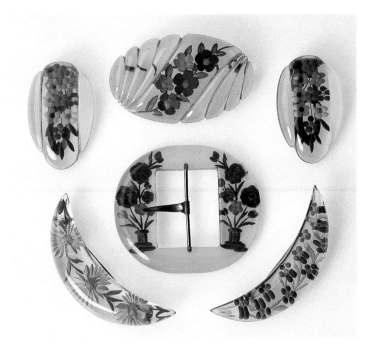

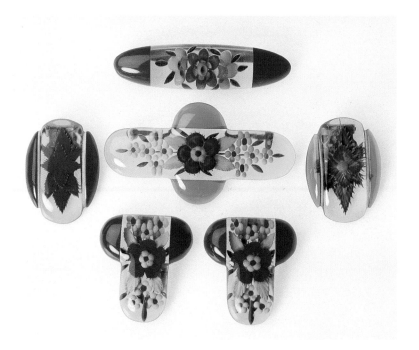

The best of the best.

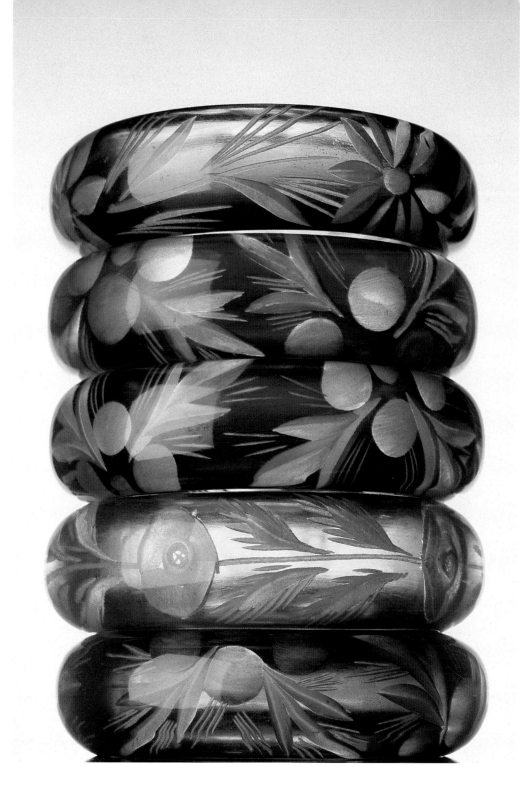

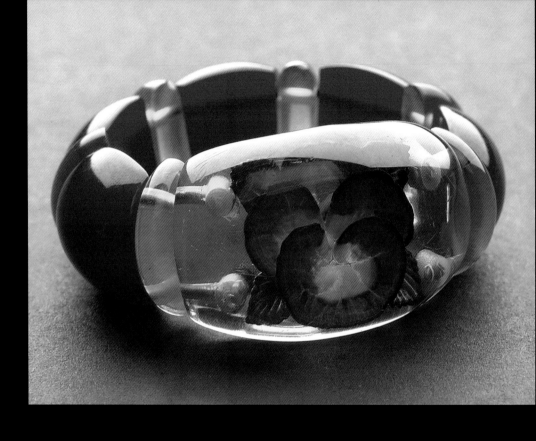

Elizabeth Smith Alster is seventy-three years old and still remembers clearly how her love affair with Bakelite jewelry began: A native Chicagoan, Elizabeth was shopping in Marshall Field's department store on June 5, 1936, trying to while away the last few hours before giving birth to her second child. There she spied

a lovely Bakelite "stretchy" bracelet with plum-colored segments and a clear center oval with undercarved pansies painted yellow and purple. She also remembers the price—$3—which by 1936 standards was high. But she was very attracted to it because "it had an arts and crafts, hand-made feeling about it, and it was

so colorful." Elizabeth thought to herself, "I'm nine months pregnant; I deserve this!" and bought the bracelet. The next day her baby was born. That bracelet was only the beginning of Elizabeth's passion for Bakelite jewelry—a passion inherited by her daughter, who, to this day, wears her mother's purple pansy bracelet!

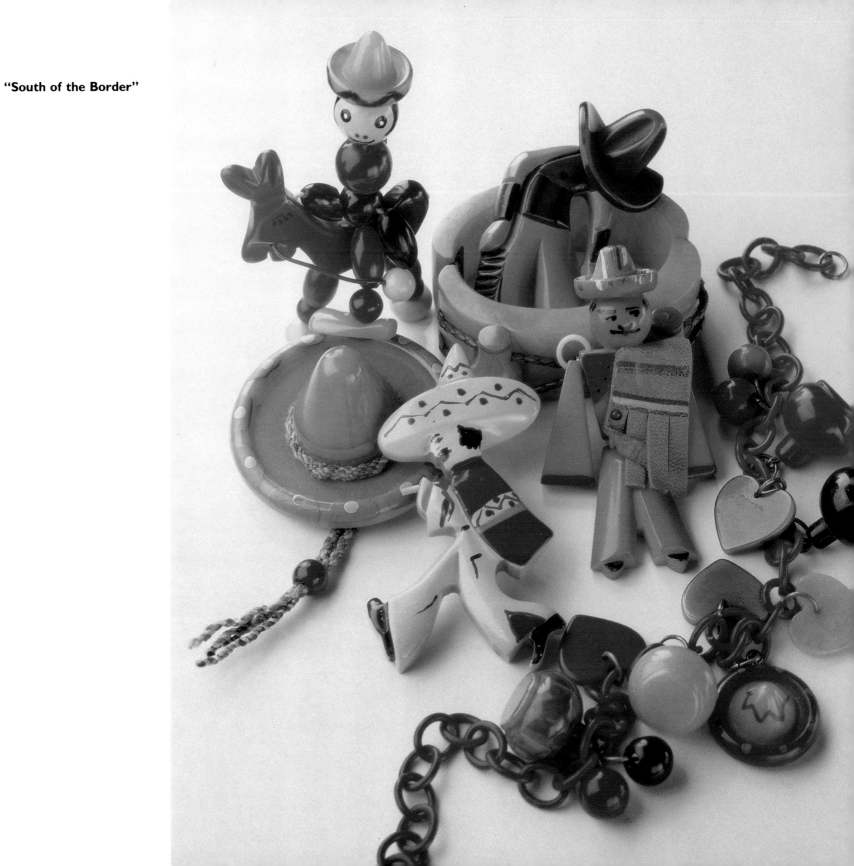

"South of the Border"

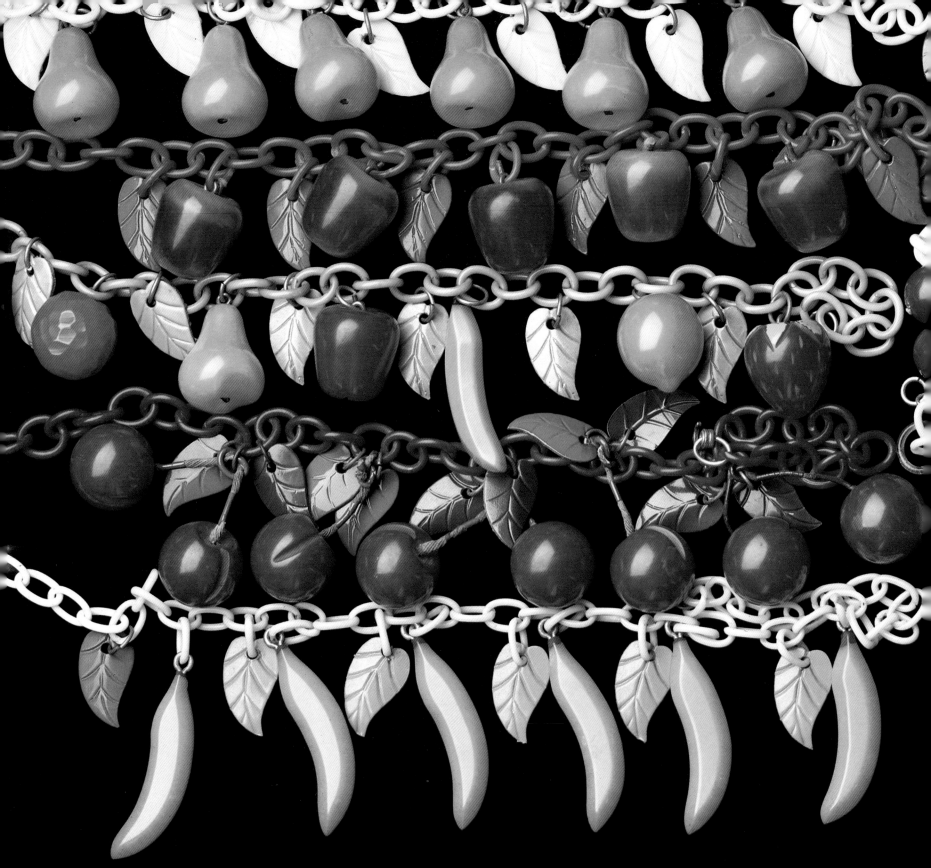

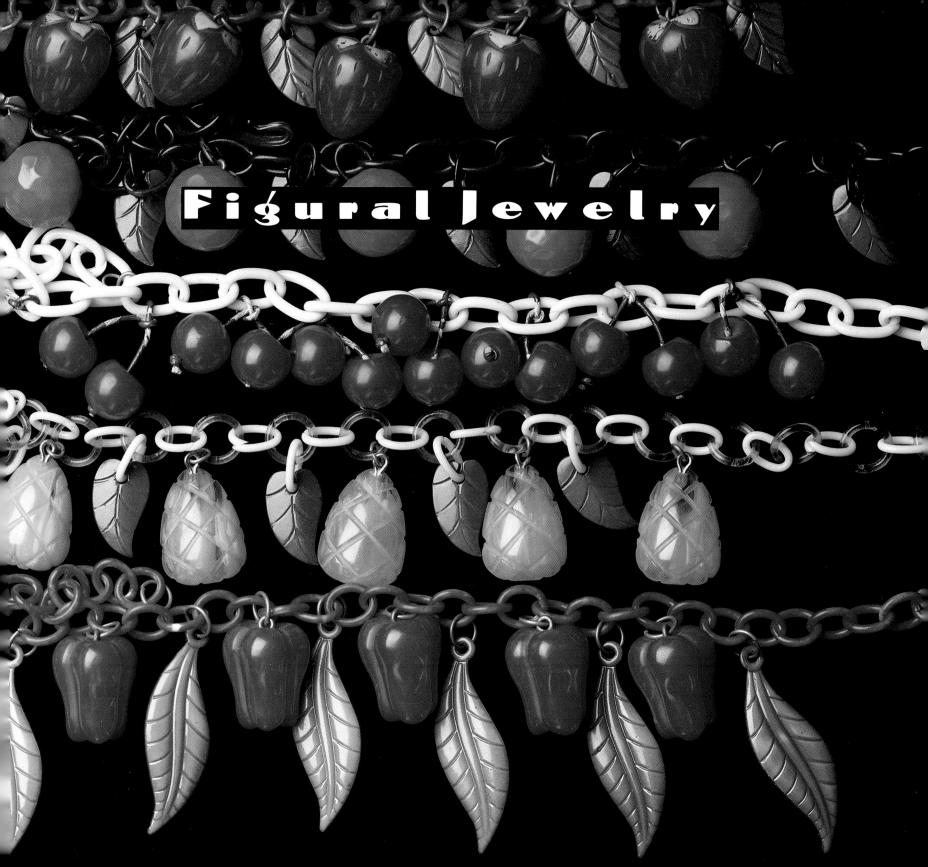

Figural Jewelry

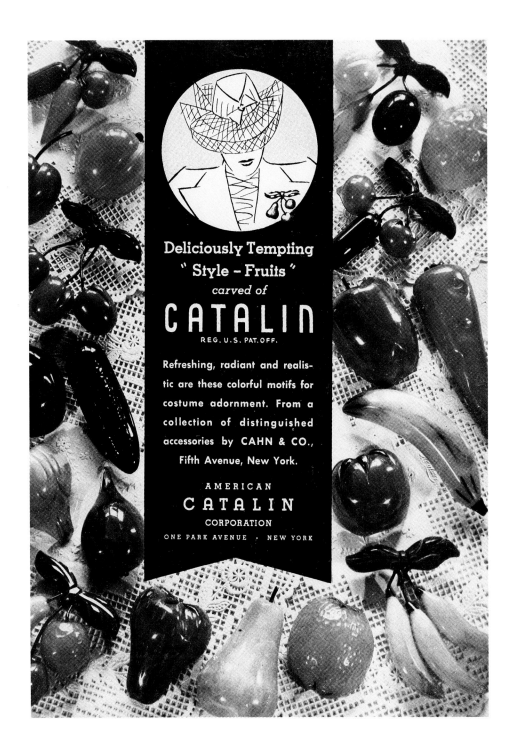
98

"You Must Have Been a Beautiful Baby"

"Want Some Seafood, Mama"

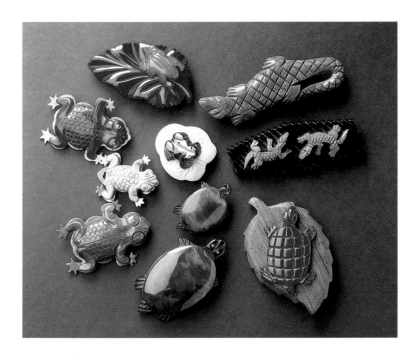

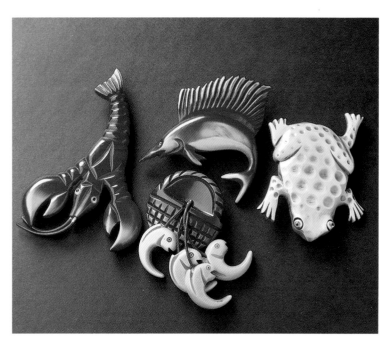

Sometime in the fall of 1935 the plastic jewelry industry underwent a transformation from streamlined deco and deeply carved floral motifs to figural themes: a change from austerity to frivolity, from the seriously sedate to the unabashedly silly, from Gauguin to Magritte, from Mother Nature to Mother Goose!

It all started with a well-carved turtle or two, a few alligators and a couple of frogs, and proceeded with astonishing ingenuity and increasing jocularity for seven years until the spirit of the world was dampened by World War II.

For the designers of figural jewelry, there was no subject too mundane or too ordinary to escape memorialization in plastic. Like the world it mimicked, all the subject matter could be divided into three categories: animal, vegetable, and mineral (or everyday man-made objects).

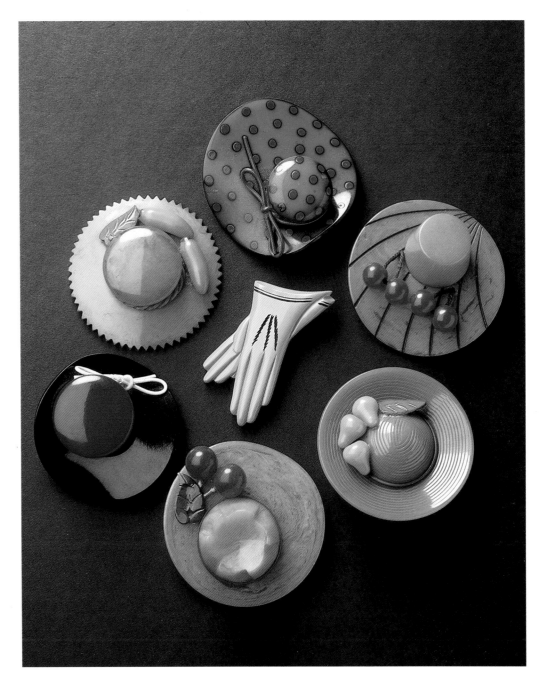

First came equestrian jewelry with horses of every variety galloping into the limelight. Only Scottie dogs (likenesses of F.D.R.'s little Fala) were more ubiquitous. Along with dogs of every pedigree were cats, birds, and hundreds of other animals, all classified under the heading of kennel jewelry. But kennel jewelry was just the tip of the iceberg (lettuce, that is), with tomatoes and potatoes and pumpkins and carrots and peas and peppers and practically every fruit known to and grown by man assembled in dangling, clattering splendor. No self-respecting thirties woman would be caught dead without her Carmen Miranda cherry necklace or banana pin!

"Keep Your Sunny Side Up"

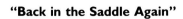

"Back in the Saddle Again"

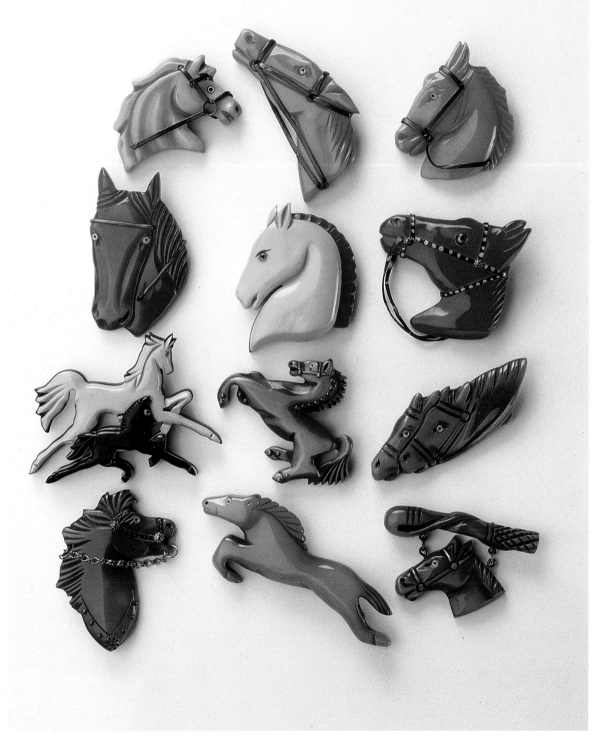

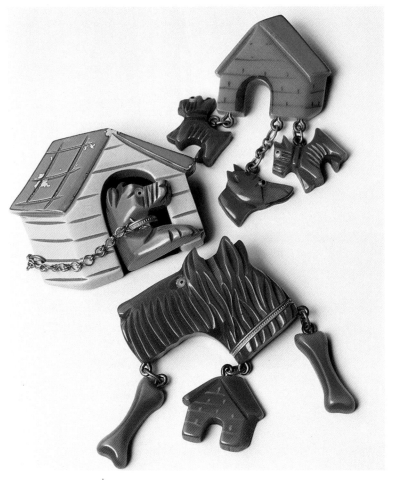

"Doggin' Around"

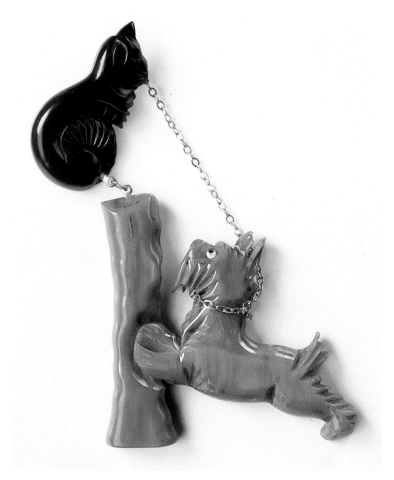

"You're the Top"

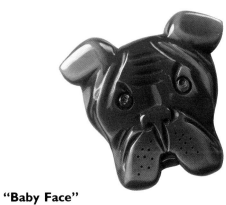

"Baby Face"

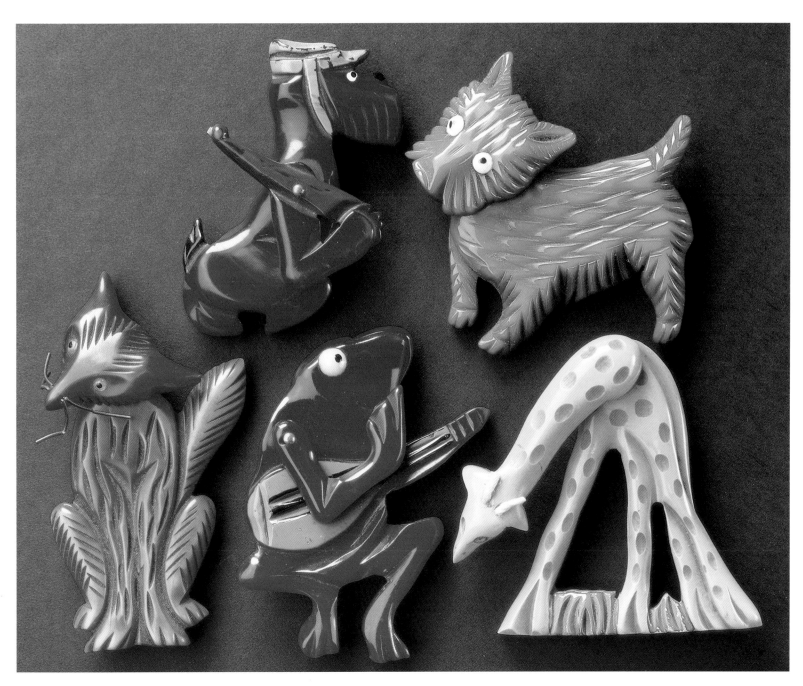

"Animal Crackers"

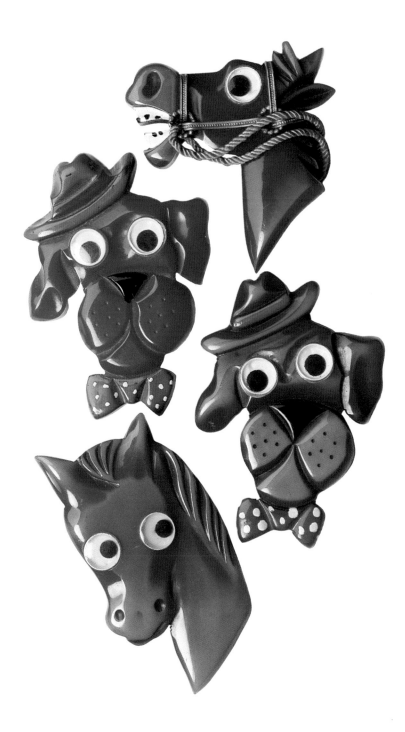

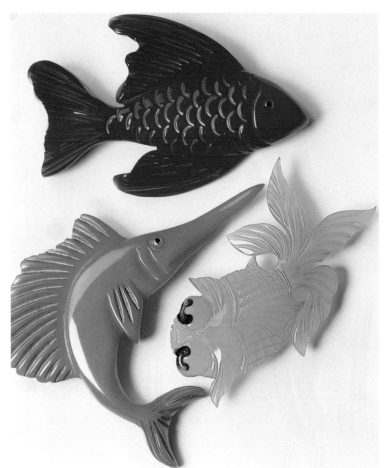

"Three Little Fishies"

106

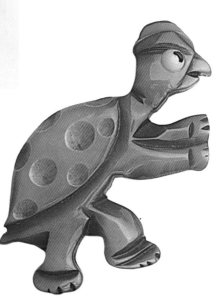
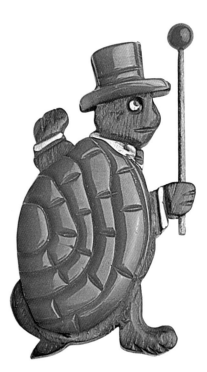

"Slow Poke"

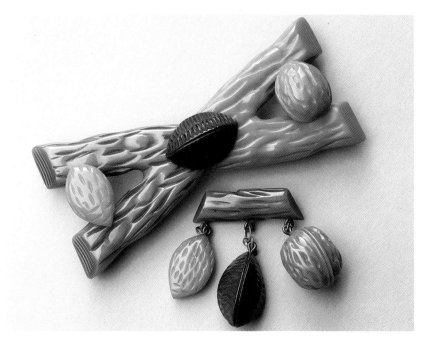

108 "I Got Plenty o' Nuttin' "

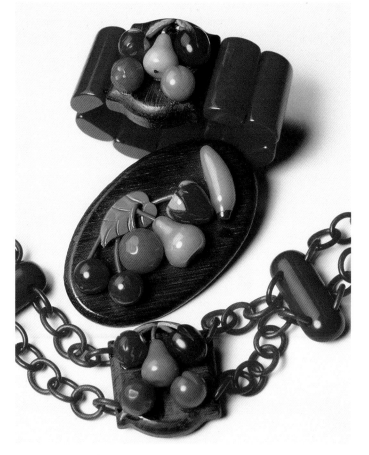

"It's Delightful, It's Delicious, It's De-lovely"

We . . .

Have . . .

No . . .
Bananas"

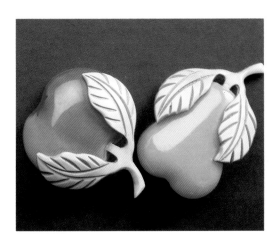

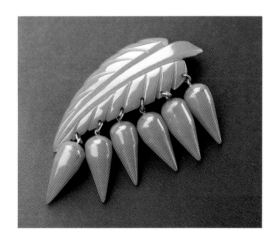

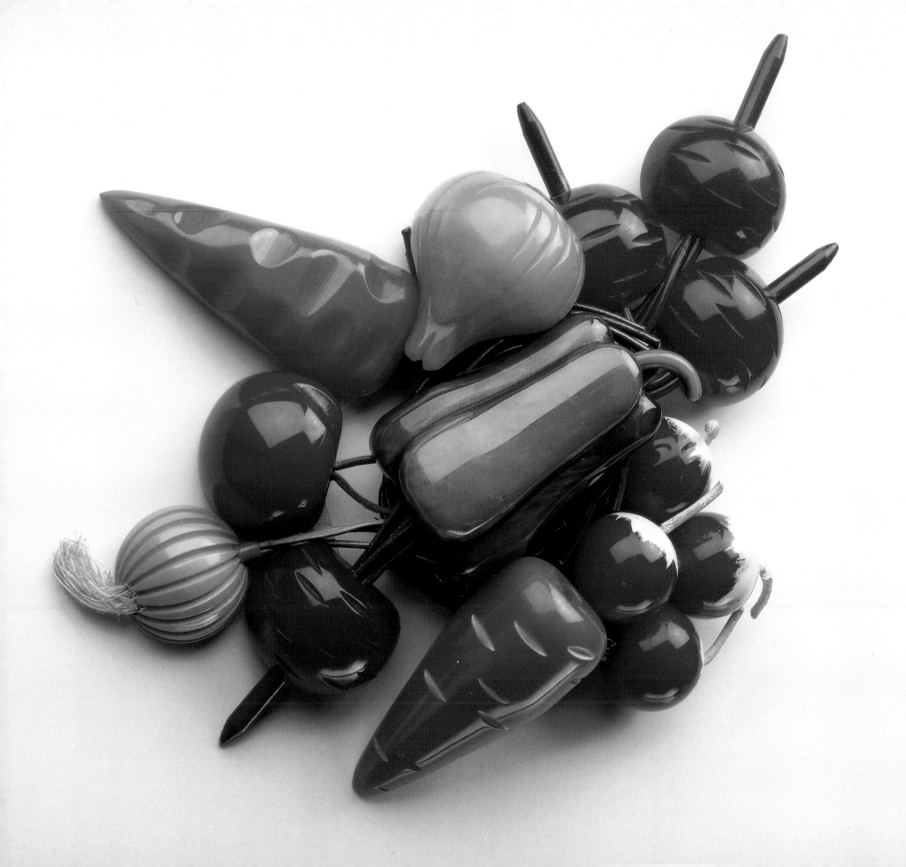

"Back in Your Own Back Yard"

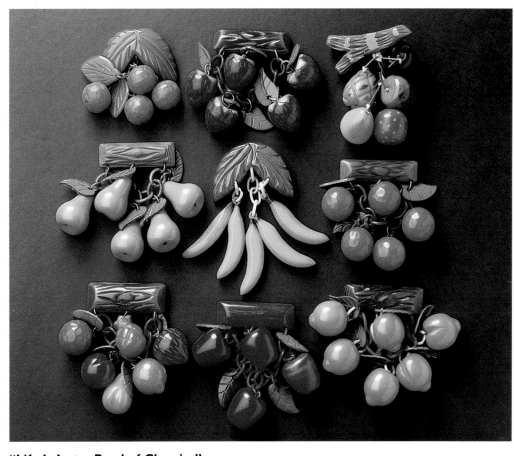

111

"Life Is Just a Bowl of Cherries"

Then came cruise jewelry with its palm trees, pineapples, sea shells, and swordfish, and nautical jewelry with its sailboats, ships' wheels, anchors, flags, and anything that floated. From England came heraldic jewelry, with knights in armor, lions, unicorns, griffins, and coats of arms fashioned from Bakelite and gilded metal. And do not forget sports jewelry, the pins and necklaces that paid homage to those great all-American pastimes: football, basketball, baseball, boxing, and bowling.

112

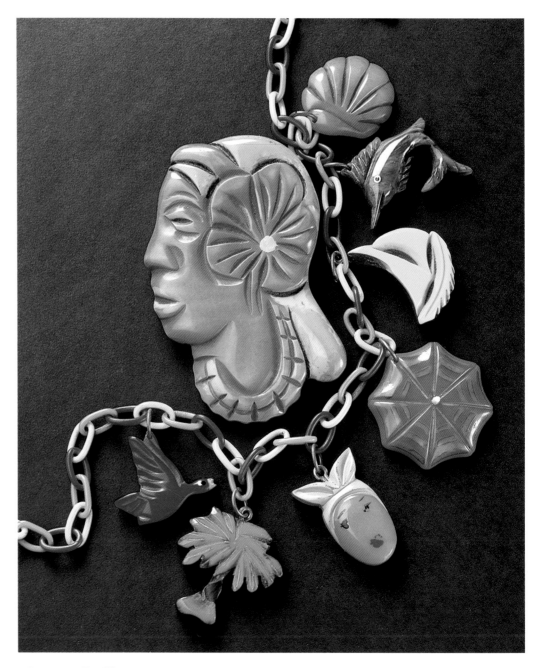

"Sweet Leilani"

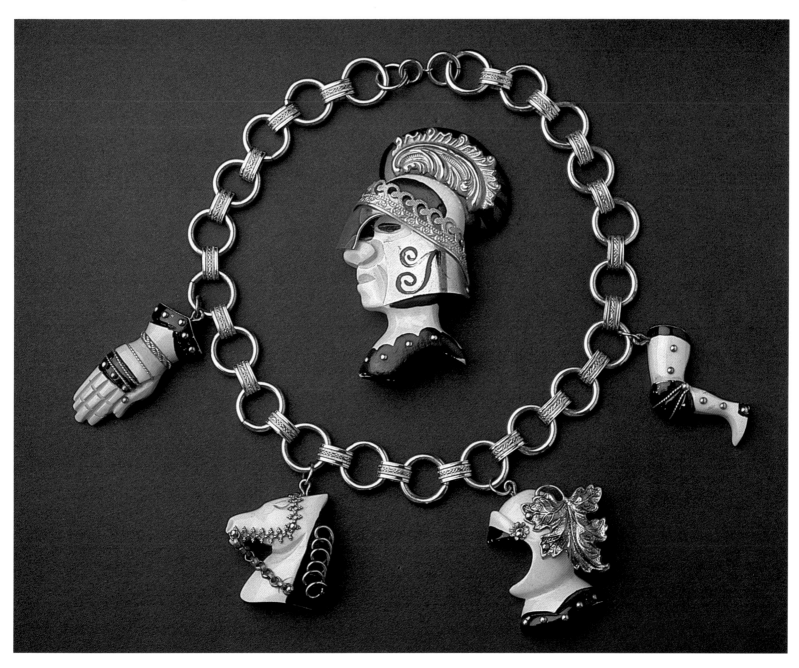

"Someday My Prince Will Come"

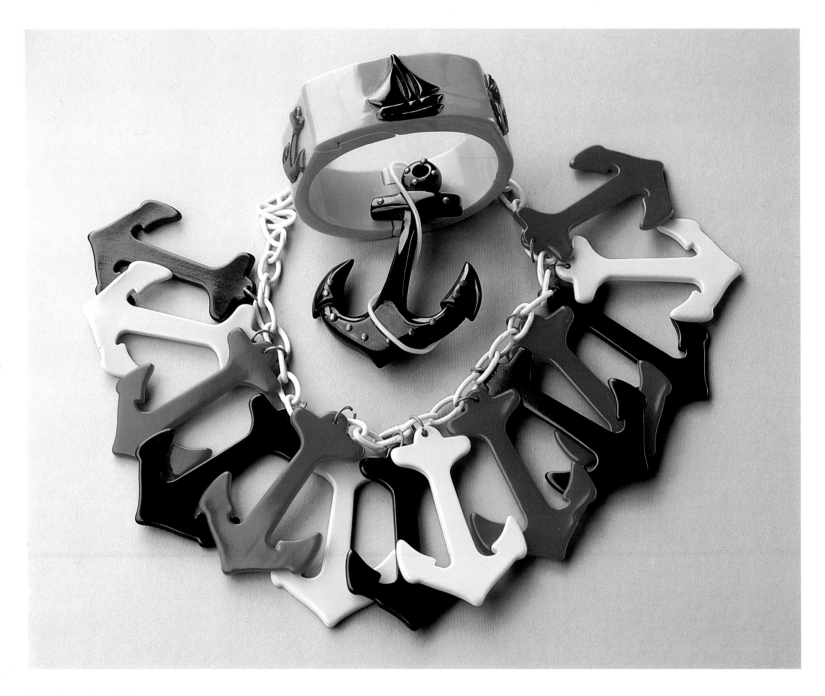

114

"Anchors Aweigh"

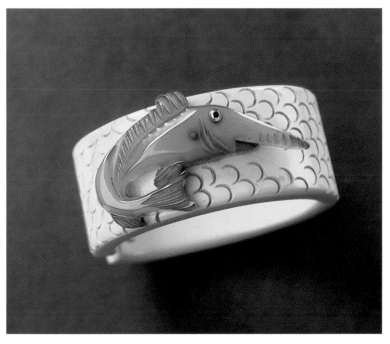

"Gone Fishin' "

"Beyond the Blue Horizon"

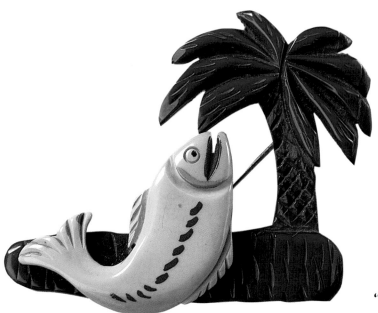

"Blue Hawaii"

"I Get a Kick out of You"

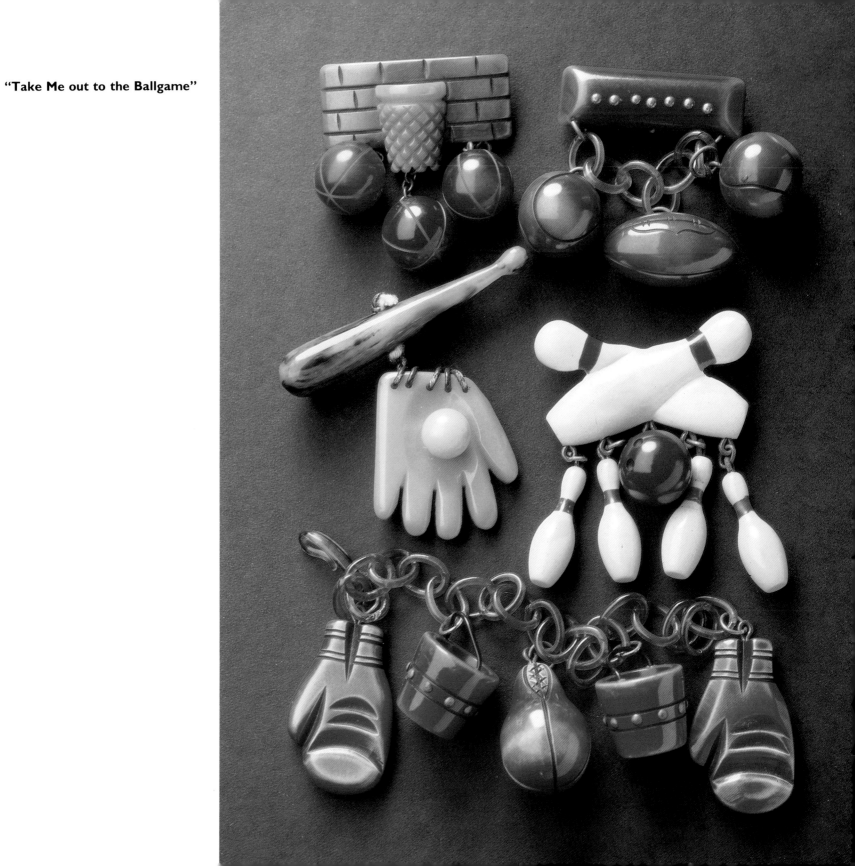

"Take Me out to the Ballgame"

Designers were up against a fickle, ever-changing market. There was no resting on laurels; they had to keep those new ideas coming. *Modern Plastics* intoned: "The profit in novelty jewelry comes from the *novelty* of the jewelry." Some of the designs produced were so odd that it was almost as if a stumped designer sat at his desk staring at his pencil and suddenly shouted "Eureka!—pencil necklaces! They'll love 'em!" And everyone *would* love them because a pencil was quite a charming thing once you really looked at it, and sixteen of them on a necklace were certainly sixteen times as charming.

118

"Don't Fence Me In"

"Pass that Peacepipe"

"Skylark"

"I'll String Along with You"

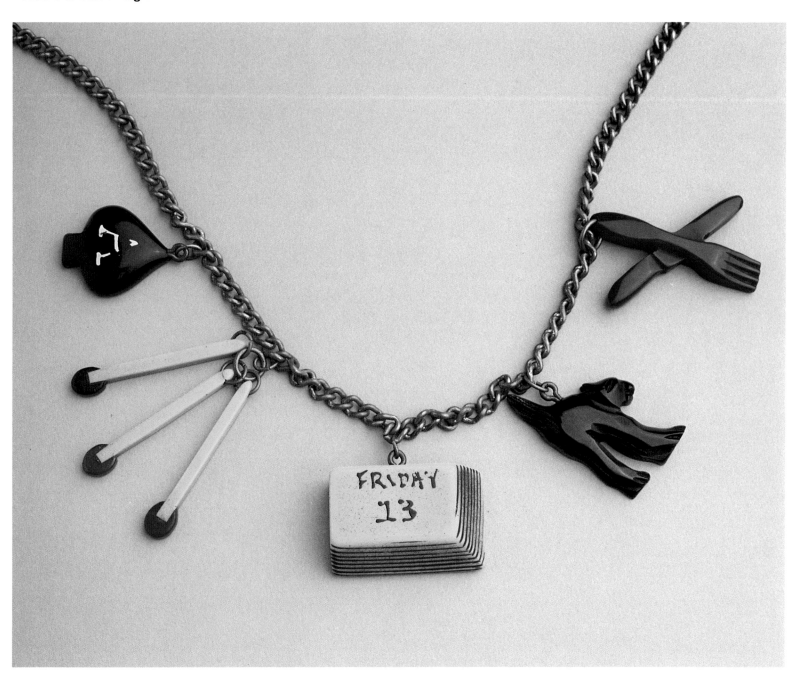

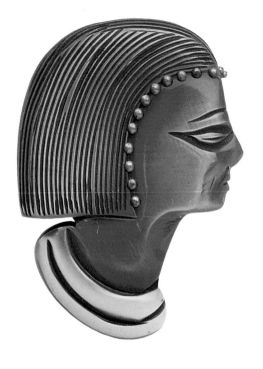

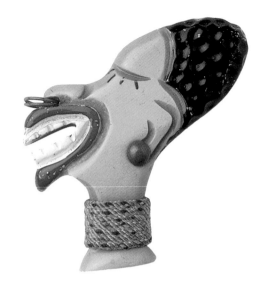

God's

"All

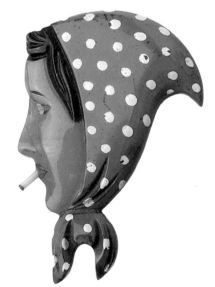

Chillun

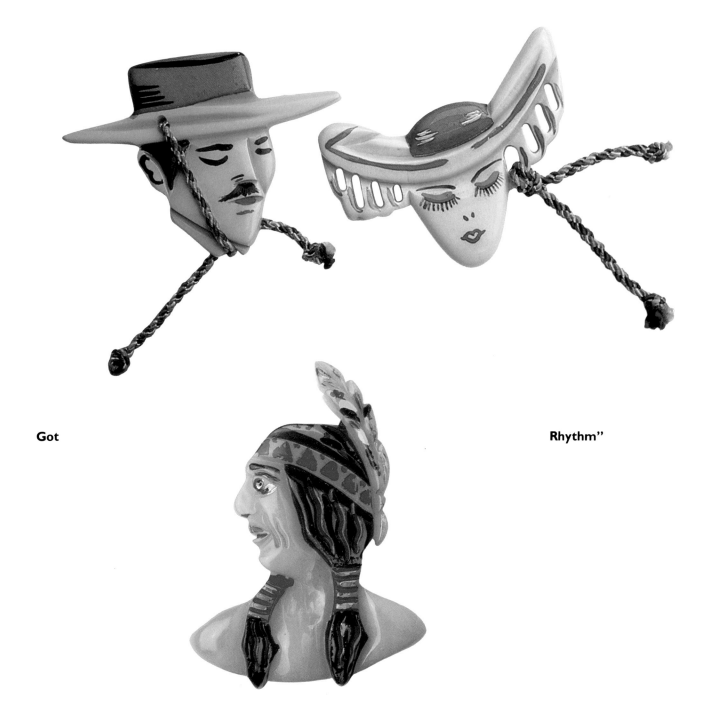

Got

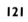
121

Rhythm"

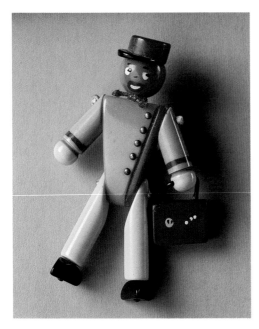

"The Chattanooga Choo-Choo"

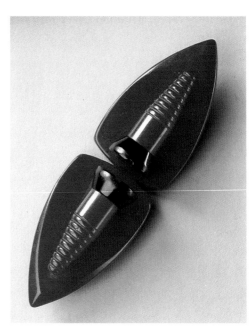

"These Foolish Things Remind Me of You"

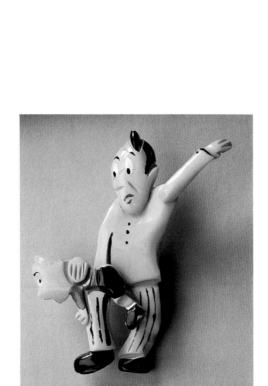

"You Always Hurt the One You Love"

By December 1937, commonplace subjects for figural jewelry had been thoroughly exhausted, and the stage was set for the star designer of the era to emerge and lead a sinking ship to safe harbor. This was Martha Sleeper, a beautiful and talented actress turned designer, who, through the well-known D. Lisner Company, infused the plastics world with new life. Her outlandish ideas and novel approach to the use of plastic materials rivaled that other original across the ocean, Elsa Schiaparelli. But while Schiaparelli only dabbled in plastics, Martha Sleeper immersed herself in them.

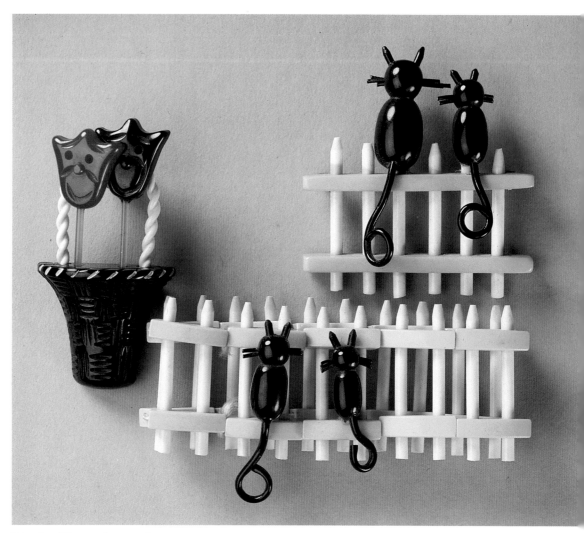

Martha Sleeper's creations.

"Smoke Gets in Your Eyes"

124

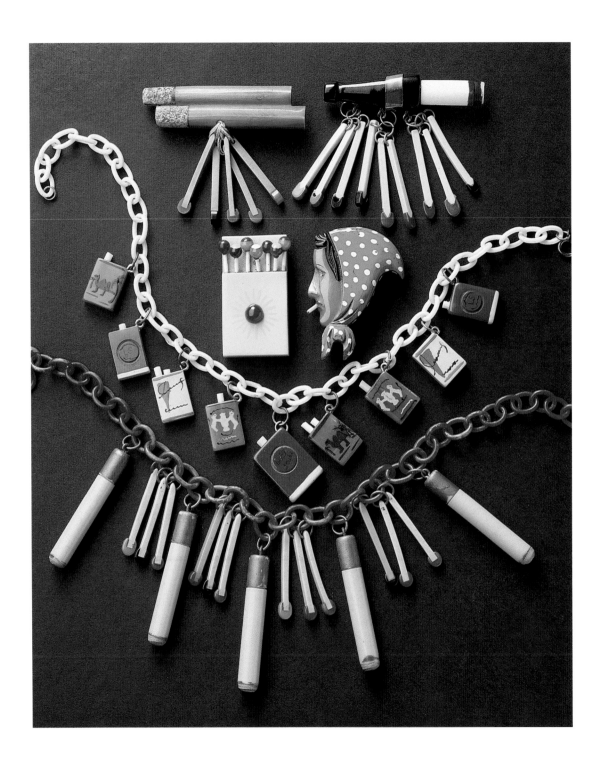

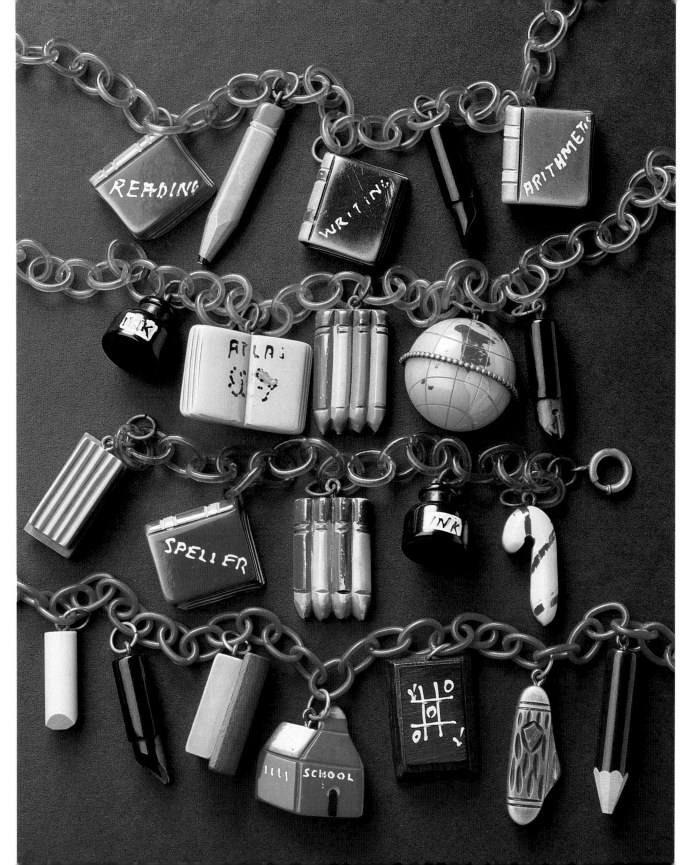

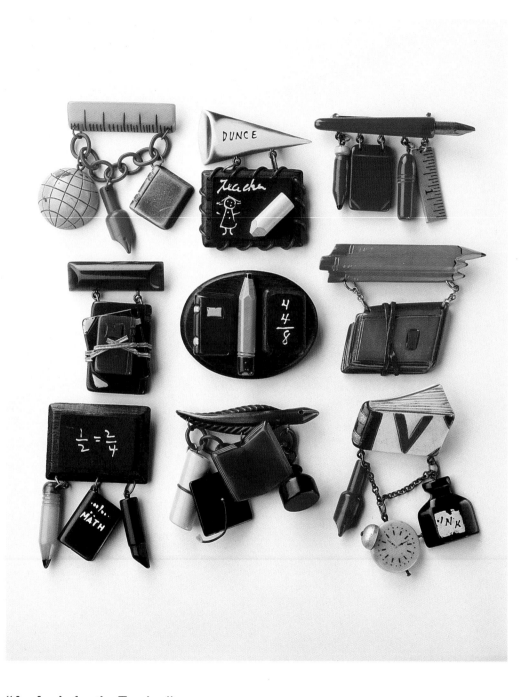

"An Apple for the Teacher"

Truly innovative, Martha Sleeper eschewed horse heads for enormous spiders, Scottie dogs for sows nursing nine little piglets, and butterflies for an entire hive of stingless bees. Her sense of fun was contagious. She created amusing little paeans to drinkin' and smokin' and stayin' out all night (all the things we in the health-conscious eighties are supposed to forego): chokers with dangling champagne bubbles and swizzle sticks, and necklaces with multicolored matches and cigarettes hanging from them. No mere pencil necklaces for her but entire schoolhouses replete with little blackboards, chalk, and erasers. When commissioned to design a line of buttons for B. Blumenthal and Company, she presented the manufacturer with a happy little celebration of circus sideshows: snake charmers, strong men, and seals with balancing balls.

Martha Sleeper combined cast phenolics with other plastics and charmed the industry with her results. Sleeper's cast phenolic cats sat on picket fences of white cellulose acetate; her wonderfully colored birds sat in cages of this same material.

The last significant amount of figural Bakelite jewelry was produced in 1941, and the subject, of course, was patriotism. Plastic "Vs" for Victory,

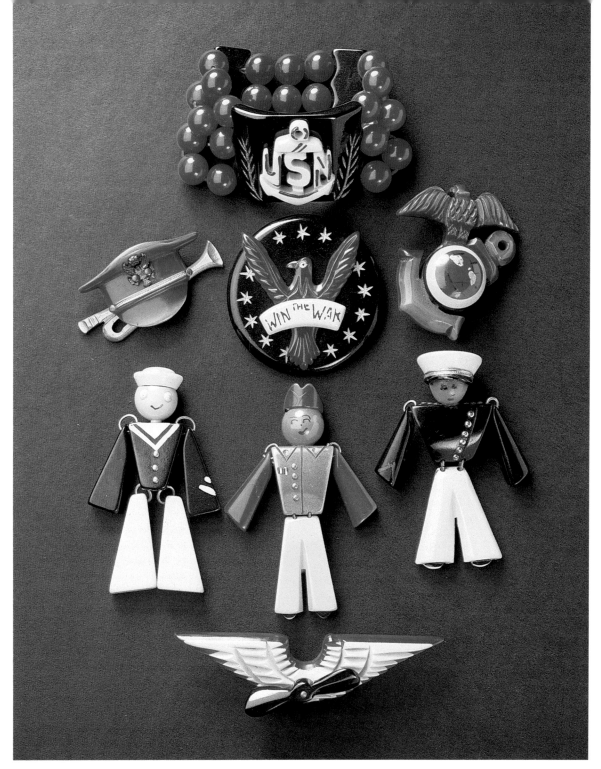

"God Bless America"

American Flag pins, and Uncle Sam hats were seen everywhere. The "heart" pin from the cover of *Life* referred to earlier was, in fact, called "The MacArthur Heart." According to an ad reproduced in Jodi Shields's book *All That Glitters,* it sold for a dollar on a red, white, and blue display card with the message: "The MacArthur Heart ... Has the Key to Our Liberty, and his Heart and Soul Is with Us."

After World War II, cast phenolics were no longer the material of choice. While this was primarily due to a changing economy and technology, it also seems appropriate emotionally. The thirties was a time of *joie de vivre,* sweet naiveté, and indomitable spirit. Somehow, it is fitting that this era, and the material that was so much a part of it, declined simultaneously. But in Bakelite jewelry, the spirit lives on!

129

"Top Hat, White Tie and Tails"

Martha Sleeper

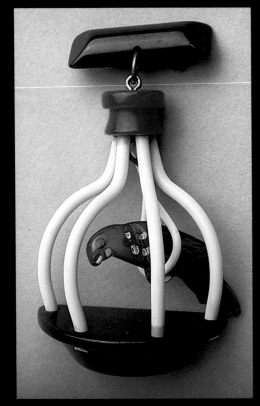

Martha Sleeper's birdcage pin.

Martha Sleeper was born in Lake Bluff, Illinois, in 1910. She had one sister, three husbands, and four different careers. She made her movie debut at the age of twelve in a Hal Roach comedy, *The Mailman,* and continued to work in "Our Gang" and Max Sennett comedies. By the time she was twenty-seven, she was married to matinee idol Hardie Allbright and already a well-known actress of stage and screen herself. Her stage performances included leading roles on Broadway in such plays as *Dinner at Eight* and *Russet Mantle.* Her movie credits included *The Scoundrel* with Noel Coward, *Danger Street,* and *West of the Pecos.* She is best known for her role as the mother in *The Bells of Saint Mary's* in which she starred with Bing Crosby and Ingrid Bergman.

Right at the height of her acting career, however, Martha Sleeper had the opportunity to follow an avocation of her childhood: the carving and painting of novelties in wood and plastic. At a cocktail party, where she was wearing some of her homemade creations (tarantula pins and chameleon clips) a newspaperman gave her the card of a department store buyer. The buyer gave her a small order, but it was the start of something big; she so quickly built up her business that she had to turn over the manufacturing of her jewelry to the New England Novelty Company.

From 1938 to 1942 she enjoyed a position of national prominence brought about not only by her success as an actress but by the popularity of her unique designs. She received widespread publicity modeling her jewelry in fashion and plastics magazines and was dubbed the "Gadget Girl" by *Collier's* magazine in 1938. "Meet Miss Martha Sleeper," the article began, "a pretty and remarkable young lady who would rather make bugs than star in moving pictures."

After World War II, Martha Sleeper abandoned the plastic jewelry industry, married her second husband, well-to-do contractor Harry Dressler Deutchbin, and moved to San Juan, Puerto Rico. There, she began

an entirely new business: the hand-painting and silkscreening of fabrics for bathing suits and dresses. She had a well-known boutique in Old San Juan and was famous for the "Martha Sleeper Cooler," a wonderful hand-painted, tropical-looking muumuu.

By the late fifties, Martha Sleeper was divorced from her second husband and married to her third, airline pilot Cree Stelling. They made their home in Beaufort, South Carolina, where Martha, ever creative, began making dollhouses with exquisite miniature furniture.

A wonderful portrait of her appeared in the notions magazine *Dress Accessories*: "We especially like her hands. They're small and sensitive. They are not at all sophisticated. They are beautiful, capable hands that look as if they would prove themselves efficient at almost any task, be it practical or artistic, homely or exalted. We believe they are the index to Martha Sleeper."

She died in March 1983. Here's to you, Martha. You were one of a kind!

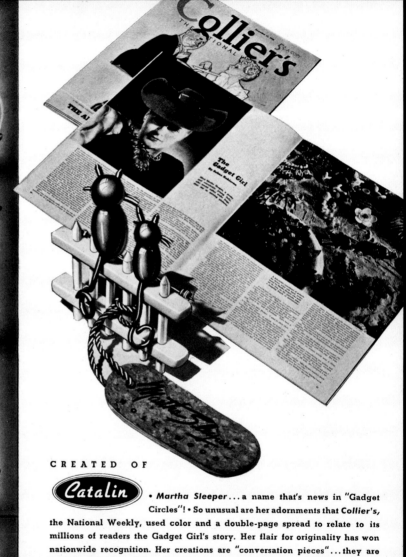

CREATED OF

Button Up Your Overcoat

The thirties were a time of madcap button-wearing. Under the influence of Schiaparelli, buttons were found everywhere—on shoulders, sleeves, and cuffs in designs that were often oversized and unusual. Eighty-five-year-old Gordon Kline, former technical editor of *Modern Plastics,* remembers that all the important manufacturers of buttons and novelties turned to Bakelite in the mid-thirties and that, for the next few years, it was the material of choice. Because its colorfulness so complemented the exuberant, vivid sportswear of the period, button companies that previously had relied on casein, wood, leather, and celluloid quickly made the switch. For buttons, Bakelite had much to recommend it. It was less expensive, easily fabricated, and light in weight, but most of all it was a material that lent itself, like no other, to a designer's every whim: no size, shape or bizarre idea seemed beyond it.

Once the button companies took to Bakelite, amusing and startling novelty buttons appeared with increasing frequency. According to a little book called *The Button Sampler,* buttons that were realistically shaped like objects were called "goofies": "buttons in the shapes of nuts, fruits, vegetables, flowers, animals, persons, toys, articles of clothing . . . were carded and sold as sets of identical buttons, sets of assorted colors, and sets of assorted objects." These buttons were inexpensive and sold for only one or two cents a piece. Today, collectors of buttons try to assemble complete sets of "goofies" or "realistics."

On reviewing button periodicals of the thirties such as *Notion and Novelty Review* and *Dress Accessories,* it becomes apparent that the important button companies enjoyed a wonderful rivalry that produced some eccentric buttons. *Modern Plastics* reported that "Grandmother's button has never boasted such a conglomeration of unusual colors, shapes and sizes," and reviews of the new fall buttons of 1936 attested to this. From the B. Blumenthal Company came road-sign buttons such as "Danger," "Curve," and "R.R. Crossing," hammers, saws and hatchets(!)

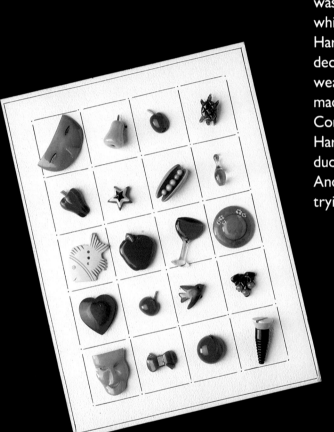

and, for evening wear, scissors set with rhinestones. From the Harlem-Adler Company came boxing gloves, chocolate kisses, binoculars, washtub stoppers, light bulbs, and whisk brooms! For the bridge player, Harlem-Adler had miniature deck-of-cards buttons, and, for dress wear, stained-glass window buttons made of Prystal. The Sterling Button Company, perhaps sensing a gap in Harlem-Adler's "utilities" line, produced buttons in the shape of irons. And the Nat Levy Company, perhaps trying to appeal to another corner of the market altogether, put out an amazing array of amphibia.

But it was not just because of their amusement value that cast phenolic buttons became so popular. Many of them, inspired by Parisian styles, were sophisticatedly abstract in design and sculptural in shape and more than worthy of the beautiful garments they adorned. An ad for the Catalin Corporation in *Modern Plastics* summed it up nicely: "Catalin buttons are really ornaments. They set off a dress as smartly as a fine piece of costume jewelry."

133

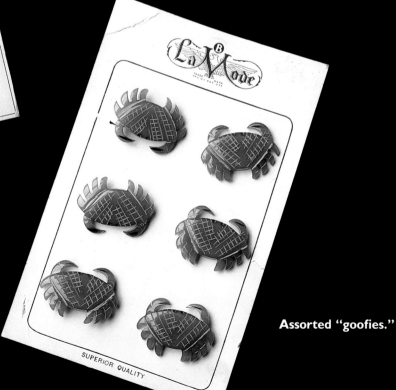

Assorted "goofies."

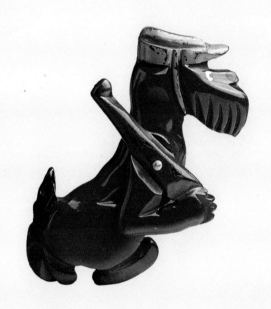

Collecting
Bakelite Jewelry

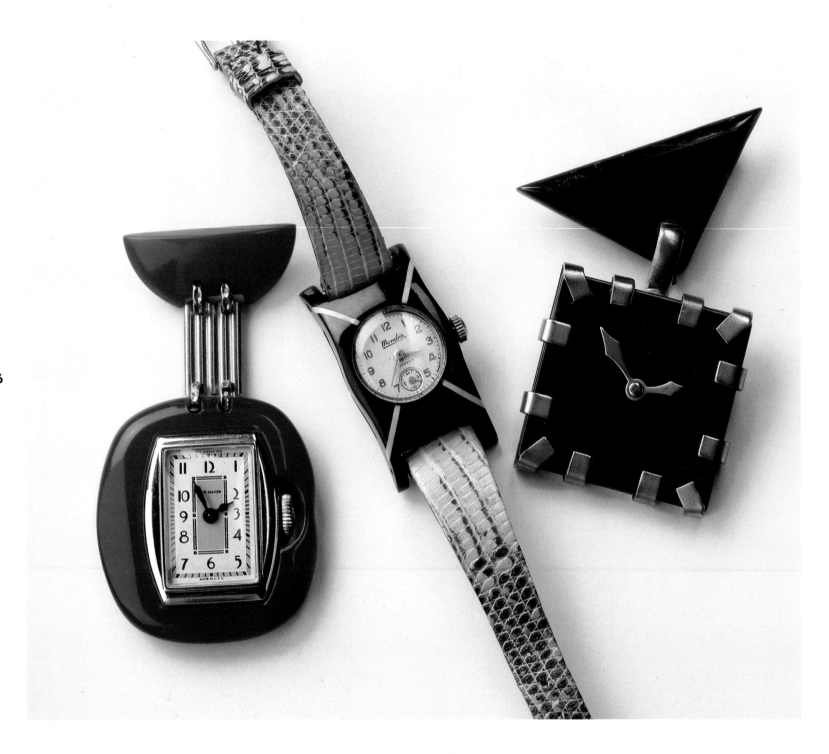

If you are about to begin collecting Bakelite jewelry, you may have some trouble distinguishing a cast phenolic from other plastics. Because it is not yet a widely collected material, many dealers do not know the differences either. Therefore, it would be best if you could locate from a reliable source a piece of the "real thing" and notice its weight, coloring, and patina. Bakelite, unless it has been refinished, is usually found in a beautiful but limited color range of red, light green, dark green, black, brown, maroon, butterscotch, orange, and cream. You will be aware of its weight—somewhat heavier than both modern plastics and celluloids. Most of all, you will notice its gemlike shine. You will want to turn a piece over and look for hinges that show their age, and screws, rivets, and pin backs that are sunk into the plastic rather than glued on. In carved pieces, look for a lack of uniformity in the carving, tool marks, and frosted areas that evaded tumble-polishing. Also, Bakelite bracelets, because they are cast, never have seams. There are certain tests that can be conducted to make sure you have found a piece of Bakelite, but, unfortunately, not until after you have purchased the piece. Stick a hot pin in the material, and if it does not penetrate you have a cast phenolic in your hands. If it melts or burns, it is not Bakelite. You can also tell by the odor it gives off when stuck with a hot pin. Celluloid smells like camphor, Galalith smells like burnt milk, and Bakelite smells like formaldehyde.

A certain amount of attention must be paid to the fact that, these days, reproductions of deco designs in materials similar to Bakelite are beginning to show up with increasing frequency; and while some of these pieces are wonderful to look at, they should not cost what an original does. Nor should "fakelite": old Bakelite pieces that have been newly reworked to improve their desirability and increase their worth (such as by gluing old buttons together to form a pin). Always either buy from a reliable source or buy cheaply.

Once you begin collecting Bakelite, you will want to know how to care for it. Since repeated exposure to

Bakelite watches.

137

"This Is the Army, Mr. Jones"

"How Deep Is the Ocean . . .

138

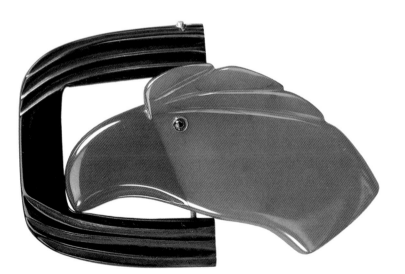

How High Is the Sky"

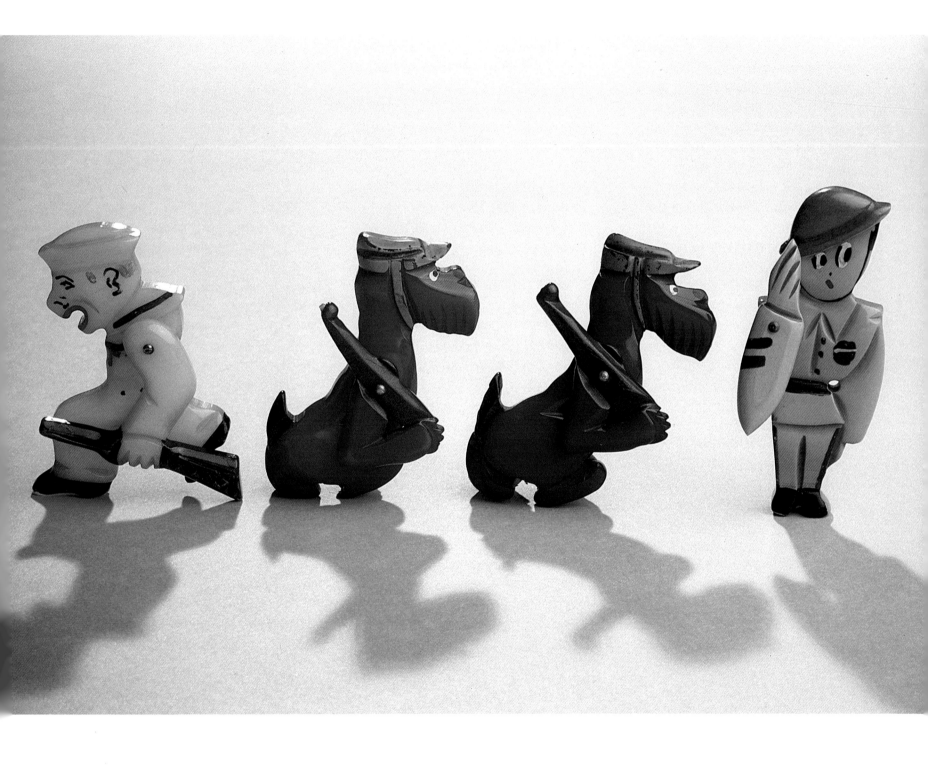

sunlight tends to yellow, darken, or fade this material, you will want to display your collection in a place that does not get too much direct sun. You must also be careful of display lights that are too hot, especially if you have pieces of Prystal, or any transparent Bakelite. Contrary to what you must be thinking, Bakelite is not fragile; it is very hardy stuff, but why take any chances?

No material responds better to polishing than Bakelite. But what to polish it *with* is another question. In our experience, plastic polishes work least well. Metal polishes like Noxon and car polishes like Turtle Wax are very good, but best of all is Simichrome, a chrome polish most often used on motorcycles!

Your best bets for finding cast phenolic jewelry are flea markets, vintage clothing stores, Art Deco galleries, and collectibles shows. While you may find a piece or two at your tonier antiques shows, Bakelite jewelry, only now fifty years old, is just beginning to qualify as a full-fledged antique—although the prices would belie that. And here's the bad news: In the last few years the prices have skyrocketed. Collectors are a ferocious breed, and as their numbers multiply so do the dollars. Only a few years back, a thick, well-carved bracelet could be found at a flea market in the $30 range. That same bracelet last year might have been priced by a knowledgeable dealer at $350. That is not to say that that same bracelet will not turn up at a yard sale today marked $10. Who can figure it?

What you can count on, should you become a collector, is a great deal of fun—something like a giant Easter egg hunt. You will meet all sorts of people, from doctors to ad men, who will share your passion and discoveries. Your conversations will be scintillating (if only to you), with exchanges like "Did you hear Cynthia snagged the 'Ape with the Movable Arm Holding a Banana' pin?" "Yeah, but I hear it's got a chip in it." Which brings us to one more point: As with every other type of collectible, condition does matter. Stay away from a cracked, chipped, broken piece, unless you just cannot live without it, and then do not pay too much for it. Be patient, and a pristine version of that piece will probably come your way.

Remember that prices fluctuate wildly according to where you find a piece, how rare it is, and what condition you find it in. Color plays an important part in determining the value of a piece. The most desirable colors are red and black. The least desirable colors are brown and certain greens. The thickness of a bangle also counts. Generally, the wider the piece is, the more valuable. In stripes and polka dots, multicolored pieces are rarer and more costly than two-tone pieces. In carved jewelry, the more elaborate the carving, the more desirable. Certain pieces are valuable simply because of their unique subject matter, and certain pieces are expensive because they are one-of-a-kind, possibly the work of a thirties home-craftsman or renegade machinist.

Because of all the above reasons, it is difficult to put an exact price on a typical piece of Bakelite. The following price guide is only intended as a starting point. Experience will take you the rest of the way. In the meantime, happy hunting and good luck!

"The Kneebone's Connected to the . . ."

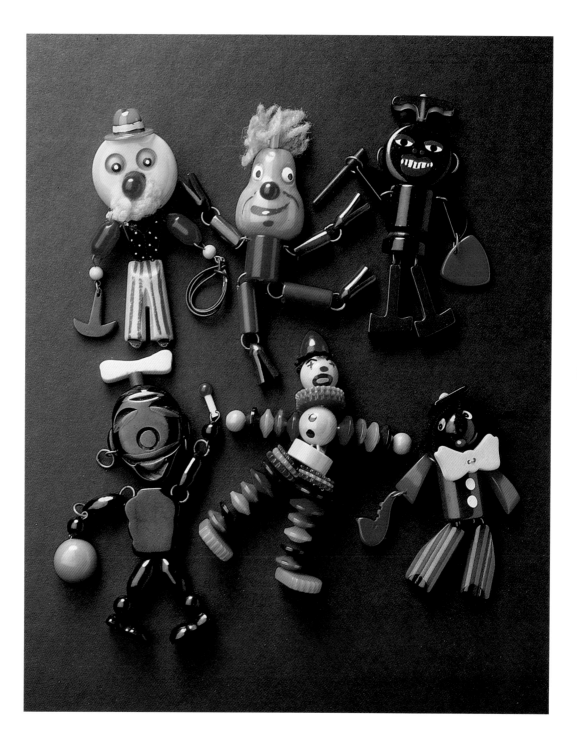

A Price Guide
to Bakelite Jewelry

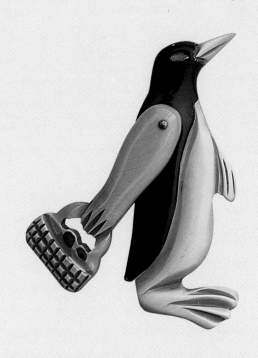

Geometric Jewelry

Type	Description	Good	Better	Best*
Bangle bracelets	one color	$15–30	$30–60	$60–100
	stripes and dots	40–80	80–120	120–400
	geometric designs	50–90	90–130	130–450
Hinged bracelets	one color	20–40	40–70	70–110
	stripes and dots	50–100	100–200	200–1000
	geometric designs	75–125	125–250	250–1000
	with wood	25–50	50–150	150–250
	with rhinestones	25–50	50–150	150–350
	with metal	35–75	75–150	150–500
Link bracelets	one color	20–40	40–70	70–110
	two or more colors	50–75	75–125	125–250
Stretch bracelets	one color	15–30	30–75	75–125
	two color	30–75	75–125	125–175
	multicolor	75–100	100–150	150–400
Cuff bracelets	all designs	20–50	50–100	100–250
Necklaces and beads	one color	25–50	50–100	100–250
	two color	50–100	100–200	200–300
	multicolor	100–200	200–300	300–500
	with wood	35–100	100–175	175–300
	with metal	50–125	125–250	250–700
	with rhinestones	75–100	100–200	200–450
	gometric designs	50–125	125–250	250–500

Type	Description	Good	Better	Best*
Pins and brooches	one color	$15–35	$35–75	$75–100
	stripes and dots	25–50	50–100	100–400
	geometric designs	35–60	60–125	125–450
	with wood	15–35	35–75	75–150
	with metal	25–50	50–100	100–400
Rings, earrings, clips buttons, and buckles	all designs	10–35	35–60	60–150

* "Good, Better, Best" applies to design, condition, color, craftsmanship, and rarity.

Carved Jewelry

Type	Description	Good	Better	Best
Bangles	½″	$15–50	$50–100	$100–225
	1″	35–75	75–150	150–350
	2″	50–100	100–200	200–450
	2½″	75–125	125–250	250–500
Hinged	1″	50–100	100–200	200–400
	2″	75–125	125–225	225–475
Link		40–80	80–120	120–300
Cuff		40–80	80–120	120–300
Stretch		40–80	80–120	120–300
Necklaces and beads		20–40	40–80	80–200
Pins		50–100	100–200	200–300
Rings		50–100	100–150	150–200
Earrings, clips, buttons, and buckles		25–50	50–75	75–150

146

Clear Carved Jewelry

Type	Description	Good	Better	Best
Bangles	floral	$ 50–100	$100–150	$150–350
	geometric	75–125	125–200	200–400
	fish motif	100–200	200–300	300–475
Hinged	floral	75–125	125–175	175–375
	geometric	100–150	150–200	200–450
	fish motif	125–225	225–325	325–500
Link	floral	75–125	125–175	175–375
Cuff	fish motif	125–225	225–325	325–500
Stretch	floral	35–75	75–125	125–200
Necklaces	floral	65–125	125–200	200–300
	fish motif	100–200	200–300	300–500
Pins and brooches	floral	30–50	50–100	100–250
	geometric	50–100	100–150	150–275
	fish motif	75–125	125–175	175–300
Earrings, clips, rings, buttons, and buckles	all designs	10–50	50–100	100–150

147

Figural Jewelry

Type	Description	Good	Better	Best
Charm bracelets	fruits and vegetables	$50–100	$100–200	$200–400
	sports, school themes	75–125	125–225	225–425
	hearts and flowers and other themes	50–100	100–200	200–450
Hinged bracelets	all designs	75–125	125–225	225–425
Stretch bracelets	all designs	50–100	100–200	200–400
Necklaces	fruits and vegetables	60–125	125–250	250–750
	sports, school themes	125–200	200–300	300–750
	smoking and drinking	125–200	200–300	300–750
	hearts and flowers	75–175	175–275	275–750
	military, nautical, and other themes	75–175	175–275	275–750
Pins	dogs and horses	25–75	75–125	125–500
	animals, sea creatures	50–100	100–200	200–500
	fruits and vegetables	50–100	100–200	200–500
	sports and school themes	50–100	100–200	200–500
	hearts and flowers	35–85	85–175	175–500
	faces, hats, and hands	35–85	85–175	175–500
	Mexican and cowboy	50–100	100–200	200–500
	jointed figures	100–175	175–275	275–500
	military, nautical, and other themes	25–75	75–125	125–500
Earrings, clips, rings, buttons, and buckles	all designs	15–50	50–100	100–150

"P.S. I Love You"

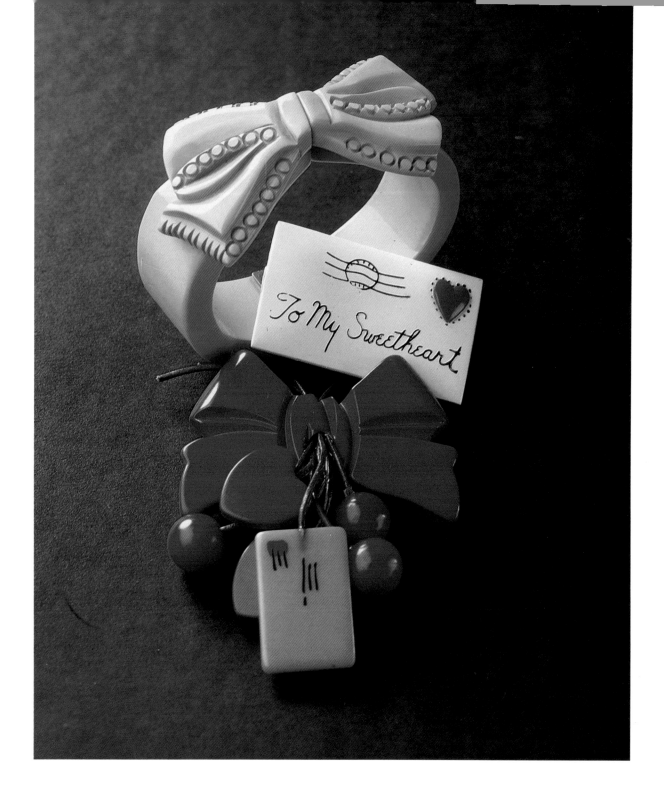

Bibliography

Albert, Lillian Smith, and Jane Ford Adams. *The Button Sampler.* New York: Gramercy Publishing, 1951.

Alferj, Pasquale, and Francesca Cernia. *Gli Anni di Plastici* (The Plastic Years). Milano: Electa Editrice, 1983.

Bakelite Molded. New York: The Bakelite Corporation, 1936.

Batterberry, Michael and Ariane. *Fashion, The Mirror of History.* New York: Greenwich House, 1982.

Battersby, Martin. *The Decorative Twenties.* New York: Collier/ Macmillan, 1961.

———. *The Decorative Thirties.* New York: Walker and Co., 1971.

Becker, Vivienne. *Antique and Twentieth Century Jewellery.* New York: Van Nostrand Reinhold, 1982.

Bush, Donald J. *The Streamlined Decade.* New York: Braziller, 1975.

DiNoto, Andrea. *Art Plastic.* New York: Abbeville Press, 1984.

Dubois, J. Harry. *Plastics,* 3rd ed. Chicago: American Technical Society, 1945.

———. *Plastics History U.S.A.* Boston: Cahners Books, 1972.

———, and Frederick W. John. *Plastics,* 6th ed. New York: Van Nostrand Reinhold, 1981.

Fielding, T. J. *History of Bakelite Limited.* London: Bakelite Limited, undated.

Ginsburg, Madeline, Avril Hart, and Valerie D. Mendes. *Four Hundred Years of Fashion.* London: Victoria and Albert Museum, William Collins and Sons, 1984.

Glassner, Lester, and Brownie Harris. *Dime-Store Days.* New York: Viking Press, 1981.

Grief, Martin. *Depression Modern: The Thirties Style in America.* New York: Universe Books, 1975.

Heide, Robert, and John Gilman. *Dime-Store Dream Parade: Popular Culture 1925–1955.* New York: E. P. Dutton, 1979.

Hommage à Elsa Schiaparelli. Exposition Organisée au Pavillon des Arts Paris, 1984.

Hillier, Bevis. *The Style of the Century 1900–1980.* New York: E. P. Dutton, 1983.

Katz, Sylvia. *Plastics.* New York: Harry N. Abrams, Inc., 1984.

Kennet, Frances. *The Collectors Book of Fashion.* New York: Crown Publishers, Inc., 1983.

La Grande Vapeur. Oyonnax: Usine de l'Union Electrique, 1987.

Lockrey, A. J. *Plastics in the School and Home Workshop.* New York: D. Van Nostrand, 1940.

McClinton, Katharine Morrison. *Art Deco, A Guide for Collectors.* New York: Clarkson N. Potter, 1972.

McDowell, Colin. *McDowell's Directory of Twentieth Century Fashion.* London: Frederick Muller, 1984.

Mumford, John Kimberly. *The Story of Bakelite.* New York: Robert L. Stillson Co., 1924.

Modern Plastics Encyclopedia 1982–83. New York: McGraw-Hill, 1983.

O'Hara, Georgina. *The Encyclopaedia of Fashion.* New York: Harry N. Abrams, 1986.

Plastics Catalog, 1942. New York: Plastics Catalog Corporation, 1941.

Ransegran, William. *German Yearbook for the Plastic Material Industry.* Bonn: Keller Publishing, 1935.

Raulet, Sylvie. *Art Deco Jewelry.* New York: Rizzoli, 1985.

Robins, Natalie, and Steven M. L. Aronson. *Savage Grace.* New York: Morrow, 1985.

Ross, Josephine. *Beaton in Vogue.* New York: Clarkson N. Potter, 1986.

Schiaparelli, Elsa. *Shocking Life.* New York: E. P. Dutton, 1954.

Shields, Jody. *All That Glitters.* New York: Rizzoli, 1987.

Simonds, Herbert R., and M. H. Bigelow. *The New Plastics.* New York: D. Van Nostrand Company, 1945.

Wakeman, Reginald L. *The Chemistry of Commercial Plastics.* New York: Reinhold Publishing Corp., 1947.

White, Palmer. *Elsa Schiaparelli.* New York: Rizzoli, 1986.

Wilson, Richard G., Dianne Pilgrim, and Dickran L. Tashjian. *Machine Age in America 1918–1941,* New York: The Brooklyn Museum, 1986.

Wolfe, Bernard. *Plastics.* New York: Bobbs-Merrill, 1945.

About the Authors

Corinne Alster Davidov

A graduate of George Washington University with an M.F.A. from the American University, "Corky" Davidov is an accomplished painter whose work has been exhibited in major Washington galleries and in more than twenty U.S. embassies abroad. A mother of three, she has been a fashion illustrator for the *Washington Post* and a set designer for the Washington Ballet and is known for her paintings of Josephine Baker, Carmen Miranda, and urban landscapes. A forerunner in the study and appreciation of Art Deco objects, she and her husband Ted have, over the years, collected an outstanding array of furniture, pottery, paintings, and bronzes—not to mention a fabulous Bakelite jewelry collection!

Ginny Redington Dawes

After graduating from St. Joseph's College in Brooklyn, Ginny Redington became lead singer with a rock 'n' roll band called "Good and Plenty" that recorded for ABC Records, performed in many New York clubs, and in concerts all over the country. She went on to become a staff writer for Screengems Music, and her songs were recorded by artists such as Eddie Arnold and Sarah Vaughan. In 1974 she wrote her first jingle, "You, You're the One" for McDonald's, and has enjoyed a string of advertising hits since, including "Coke Is It," "There's More for Your Life at Sears," and "I Like the Sprite in You." In her spare time she and her husband and writing partner Tom scour the flea markets for Bakelite.

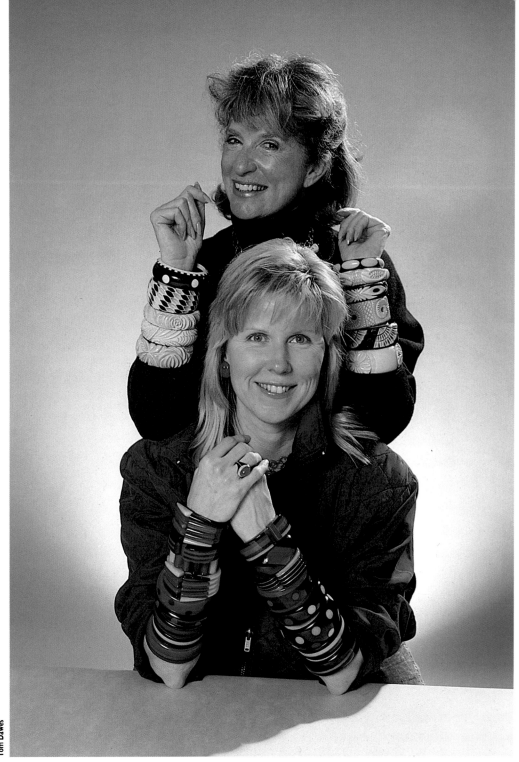

Tom Dawes

Index